Jim Henson's™
LABYRINTH™
◆ ARTIST TRIBUTE ◆

Published by
ARCHAIA™

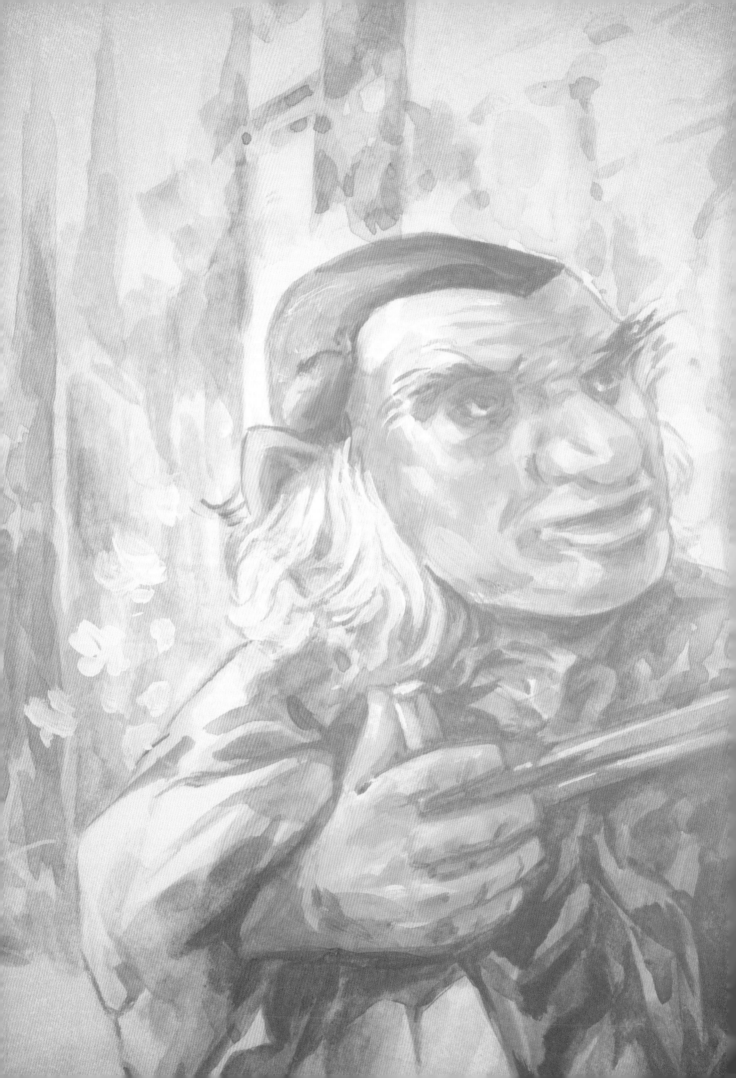

Jim Henson's™
LABYRINTH™
◆ ARTIST TRIBUTE ◆

Cover by
Steve Morris

Designers
Scott Newman & **Jillian Crab**

Assistant Editor
Cameron Chittock

Editor
Sierra Hahn

Special Thanks to Brian Henson, Lisa Henson, Jim Formanek,
Nicole Goldman, Maryanne Pittman, Carla DellaVedova, Justin Hilden,
Jill Peterson, Karen Falk, and the entire Jim Henson Company team,
as well as Brian and Wendy Froud.

THE JIM HENSON COMPANY

BOOM! Studios, 5670 Wilshire Boulevard, Suite 450, Los Angeles, CA 90036-5679.
Printed in China. First Printing

ISBN: 978-1-60886-897-1, eISBN: 978-1-61398-568-7

✦ TABLE OF CONTENTS ✦

Introduction 7	Gustavo Duarte 50
Eric Powell 9	Dave McKean 52
Tula Lotay 10	Kelly and Nichole Matthews 54
Derek Kirk Kim 11	Matías Bergara 56
Mark Buckingham 12	Ann Marcellino 57
David Mack 14	Bill Sienkiewicz 58
Dustin Nguyen 16	S.M. Vidaurri 60
Jane Burson 17	Kyla Vanderklugt 63
Jill Thompson 18	Faith Erin Hicks 64
Luke Flowers 19	Kelsey Beckett 65
Aaron Renier 21	Jim Towe 66
Craig Thompson 22	Rebekah Isaacs with Dan Jackson ... 69
Jonas McCluggage 23	Daniel Bayliss 70
Benjamin Dewey 24	Justin Hilden 72
Hannah Christenson 25	Douglas Holgate 73
Dylan Meconis 26	Katie Cook 74
Frazer Irving 27	Tyler Jenkins 77
Lily Fox 28	Mike Huddleston 78
Hayden Sherman 30	Robb Mommaerts 79
Cory Godbey 33	Matthew Fox 80
I.N.J. Culbard 34	Jorge Corona 82
Max Dalton 35	Roger Langridge 83
Jay Fosgitt 37	Michael Allred with Laura Allred 85
Jonathan Case 38	Ramón K. Peréz 86
Joëlle Jones 41	Jeff Stokely 89
Alex Sheikman 43	Dylan Burnett 91
Jake Myler 44	Steve Morris 92
Michael Dialynas 45	*The Making of the Cover* 94
Phil Murphy 46	*About the Artists* 102
Ian Herring 48	

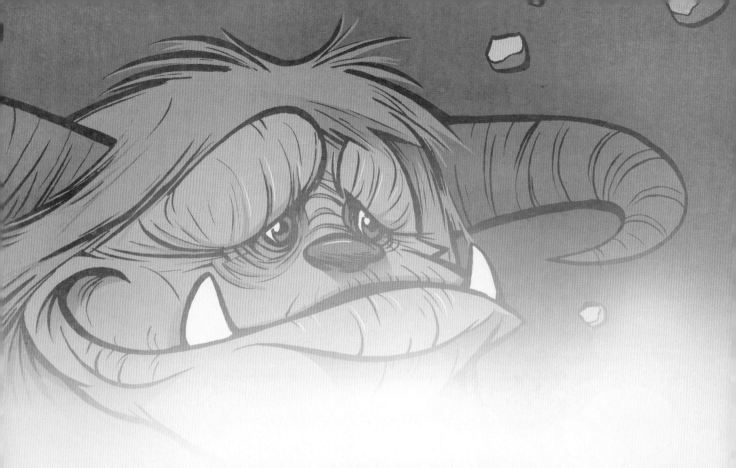

✦ INTRODUCTION ✦

In 1985, I was in Toronto shooting *Fraggle Rock*, and trying hard to be an adult.

Jim Henson, who was in London developing *Labyrinth*, sent me a copy of the screenplay and asked for my thoughts. I had problems with it: I felt Sarah was a spoiled child who was not sympathetic enough to lead the audience through the story. It further distressed me that Sarah's passage through the labyrinth was a succession of puzzles that didn't advance the plot.

Indeed, when the movie was complete, I still didn't think it worked. The box office was disappointing, and we felt a sense of failure . . . especially Jim. But time passed, and *Labyrinth* accumulated a passionate fan base. I grew, and began to feel the poignancy of leaving childhood behind. Now, thirty years on, I've raised children of my own, and *Labyrinth* touches me more deeply than ever. I love this film.

What once seemed a muddled succession of tests and obstacles now feels like life itself. Life is a labyrinth, especially when we try to hoist ourselves from one plateau to the next. We often struggle without getting anywhere. It's hard to distinguish the significant from the trivial—the clutter of life obscures the meaning. Where are we going? How will we find our way? Are we courageous enough? Must we close one door to open the next?

Labyrinth does what great art aspires to: it presents a surface experience that entertains us while delivering a deeper meaning. It's a virtuoso trick; one minute we are intrigued and amused, and the next we find ourselves gasping at the precipice of laughter or tears. I've always been fascinated by art that conveys meaning indirectly. That kind of art is hard to make.

This film is a nice example of "white space." That's a term for art that is not fully specific. You might draw some of the details of a face: an eye, a cheekbone, a turn of the mouth, and let the rest trail off . . . this allows each observer to complete the work in a way that is personal. In this manner, a single work of art can mean different things to different people. Observers become co-creators. It's a rich experience that takes you beyond the actual art, and beyond where you could have taken yourself.

Eventually, many of Sarah's issues resonated with me—obliquely rather than directly. Sarah's story is not mine, but we have things in common. *Labyrinth* is like a mirrored wind chime that occasionally gives you a glimpse of yourself, and inside you a small voice cries, "Hey, that's me!" The genius of *Labyrinth* is that it distracts you while it works on you at a deep level. It's possible to love it and have no idea why. And it's also possible to collapse in tears at the profundity of it. One of the things that resonates for me is that I've been fortunate to incorporate the playfulness of childhood into my career and life. I keep my childhood with me.

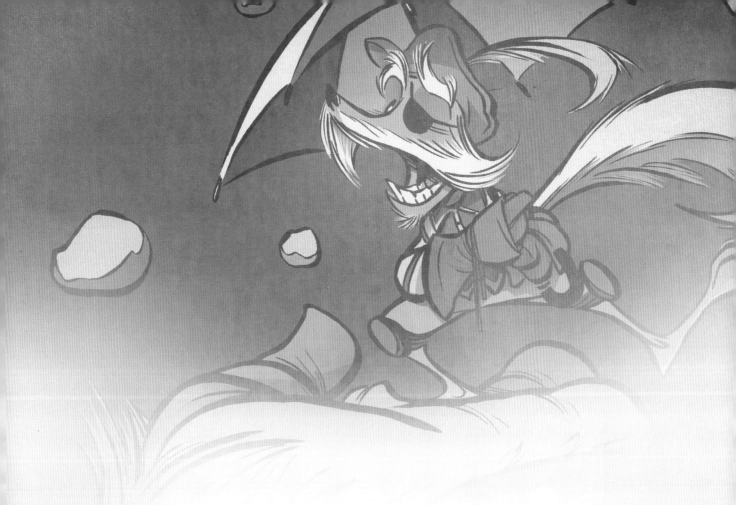

In the end, Sarah finds herself in her room. It seems the whole adventure was a dream, populated by the beloved artifacts of her childhood. As often happens in dreams, Sarah has been working to solve her life. In grappling with Jareth, she addresses both the abandonment she feels from her father, whose allegiance seems to have shifted to his new wife, and the prospect of her own involvement with young men. Is Jareth Sarah's father? Her lover? Or both? Sarah's brother represents the responsibility that comes with adulthood, and his kidnapping propels her quest. But where is Sarah's birth mother? How can a young girl reach maturity without the guidance of a role model? In the labyrinth, Sarah realizes that she can decide who will have power over her. The conflicted Hoggle and courageous Didymus have helped her navigate the passage, and she doesn't have to leave them behind. Sarah is empowered to take whatever she chooses from her childhood with her into her adult life.

My labyrinthine journey with this film has come full circle. The things I objected to then are now the parts I love most. Of course Sarah wasn't sympathetic in the beginning; she was scared. Of course she was not always likeable . . . who is? And the frustrating tasks Sarah must perform to rescue her brother represent obstacles we all must negotiate. Life doesn't always make sense. It's a labyrinth.

Jareth, Hoggle, Didymus, the goblins, the labyrinth . . . they're all festive wrapping paper, concealing the real present: The interior journey from childhood to adulthood. The white space in *Labyrinth* allows room for you to make it your story. What does this feast of spun sugar and gristle— the very stuff of life—mean? That depends on you. If you see Labyrinth merely as a collection of fantastic characters and puzzles, watch it again, and let yourself feel. Labyrinth might tell your story. Ask yourself: "Is that me?"

Do we have to leave childhood behind? This movie says "Of course not!" That's a message from the heart of Jim Henson. He was a capable adult who could still see the world from a child's point of view. He ran a complex enterprise, but was also free and playful. Those things made his life a vivid experience. His adulthood—and the world—was enriched because he carried childhood with him.

Dave Goelz
June 2016

Dave Goelz has been a principal puppeteer with The Muppets for forty-three years. Some of his characters include The Great Gonzo, Bunsen Honeydew, Zoot, Beauregard and Waldorf from *The Muppet Show*; Boober Fraggle, Traveling Matt, and Philo the Rodentia from *Fraggle Rock*. Goelz's feature film credits include all of The Muppet movies; *The Dark Crystal*, and of course, *Labyrinth*, where he performed the character Sir Didymus as well as several strange objects, including a hat and a door knocker. Goelz lives in Northern California.

"Through dangers untold
and hardships unnumbered,
I have fought my way here . . ."

Facing page: *Art by Eric Powell.* Following pages: *Art by Tula Lotay* (left) *and art by Derek Kirk Kim* (right).
Pages 12–13: *Art by Mark Buckingham.* Pages 14–15: *Art by David Mack.*

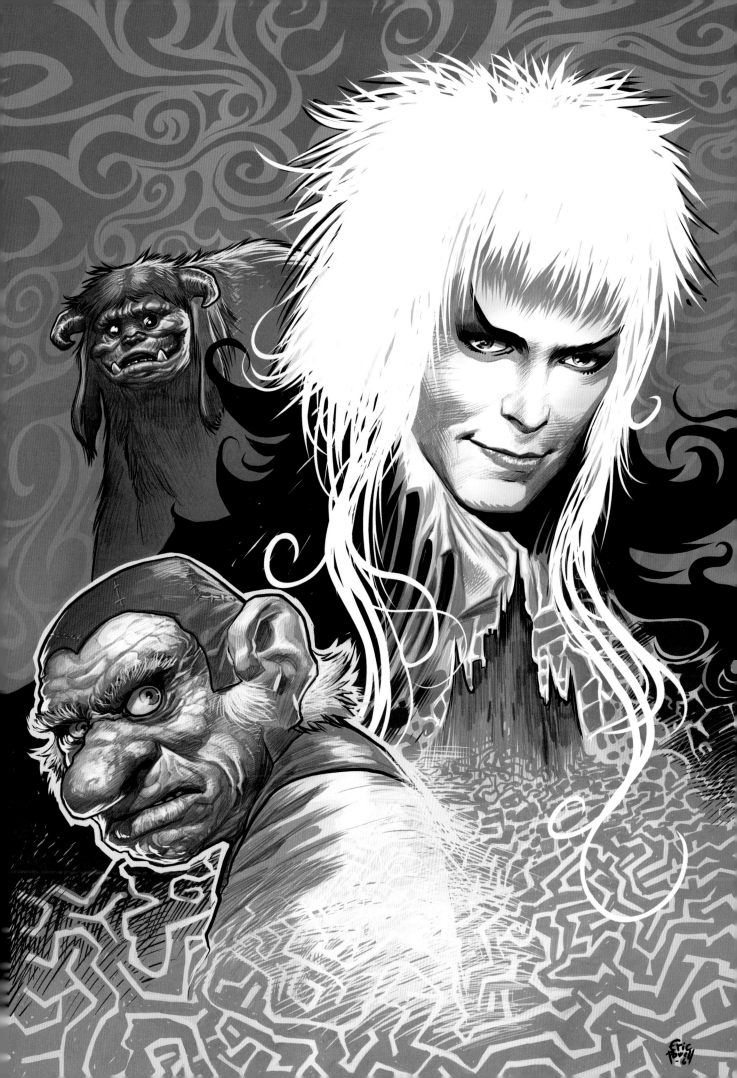

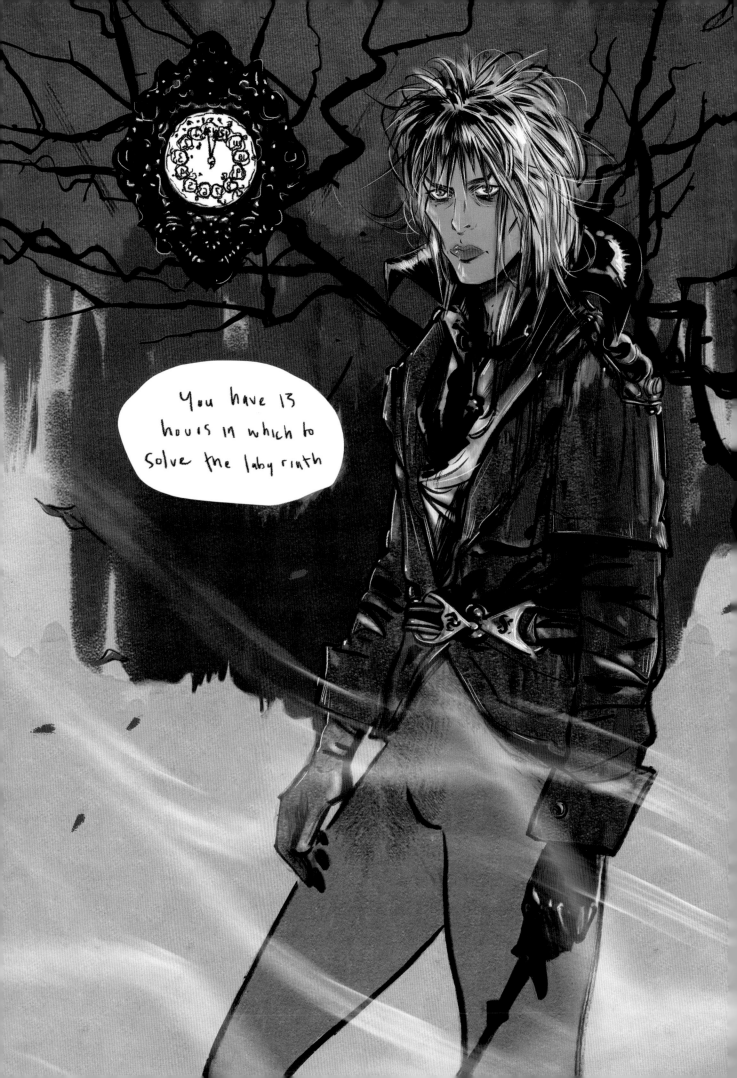

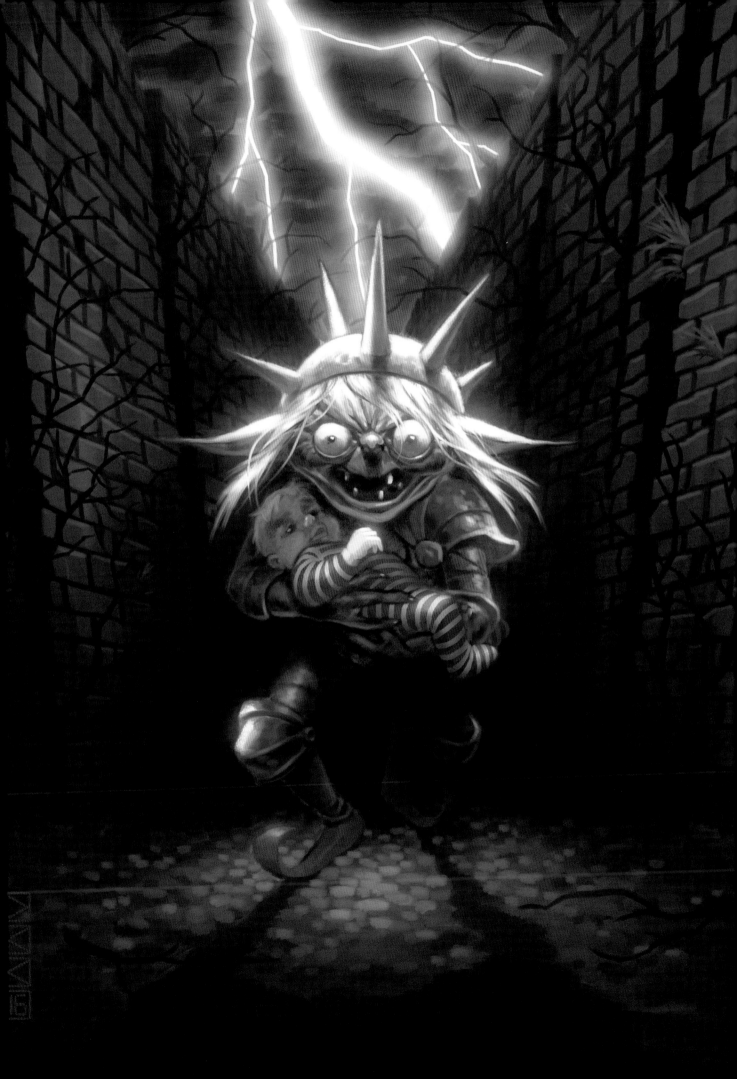

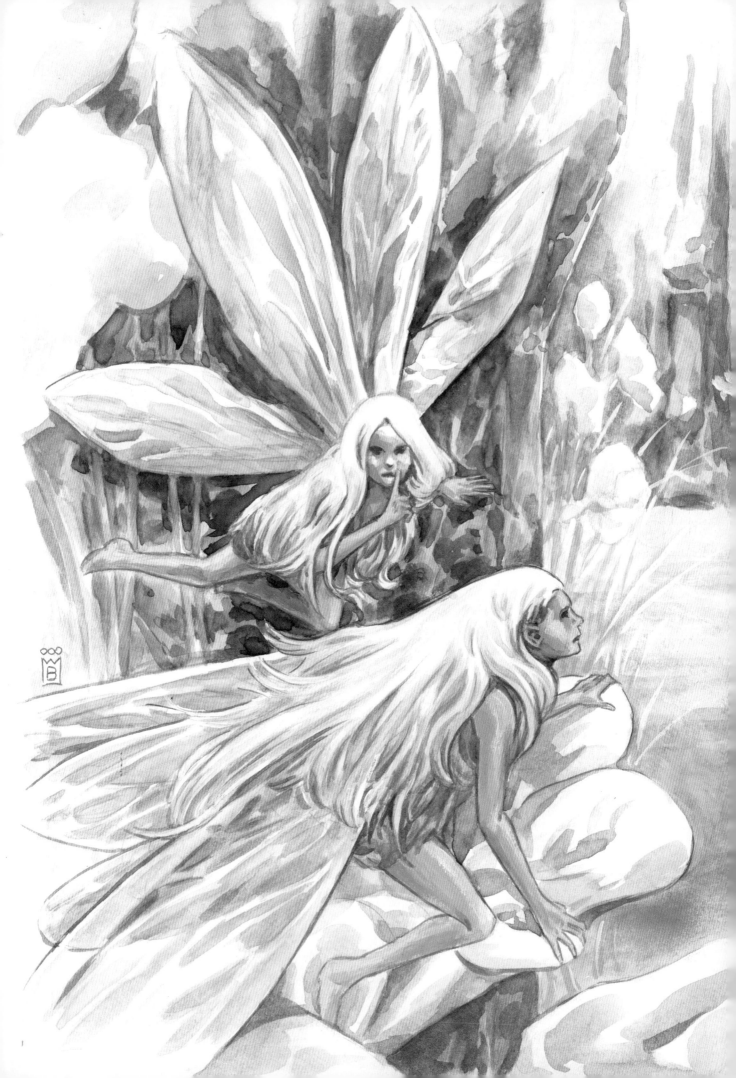

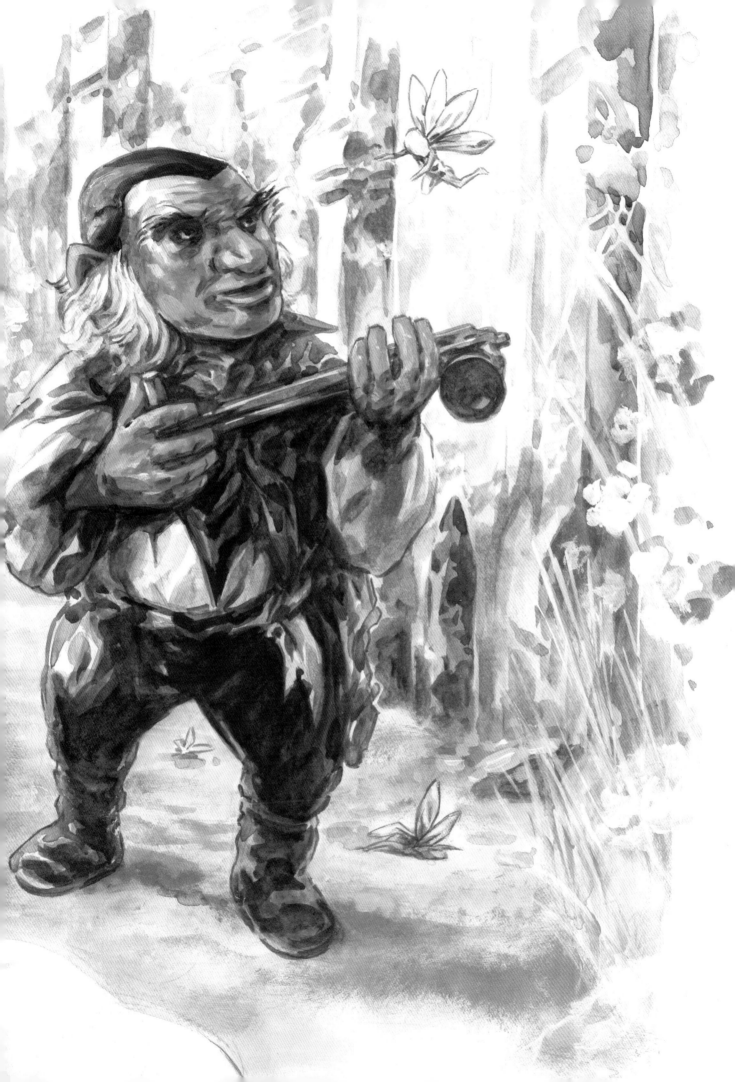

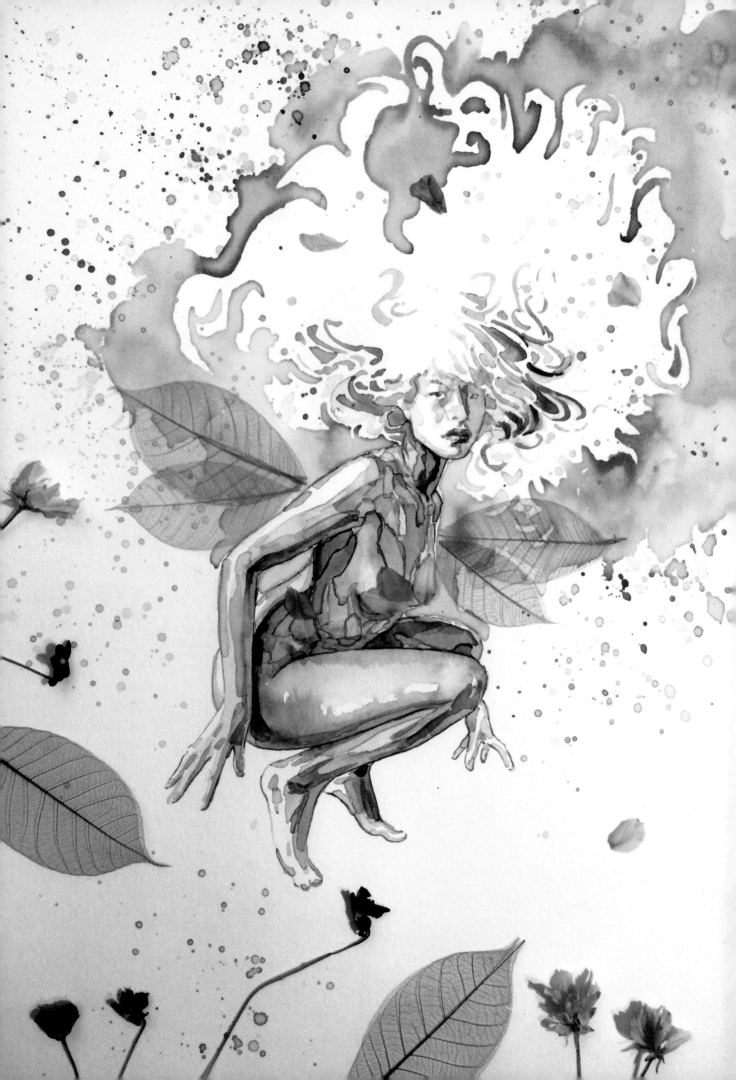

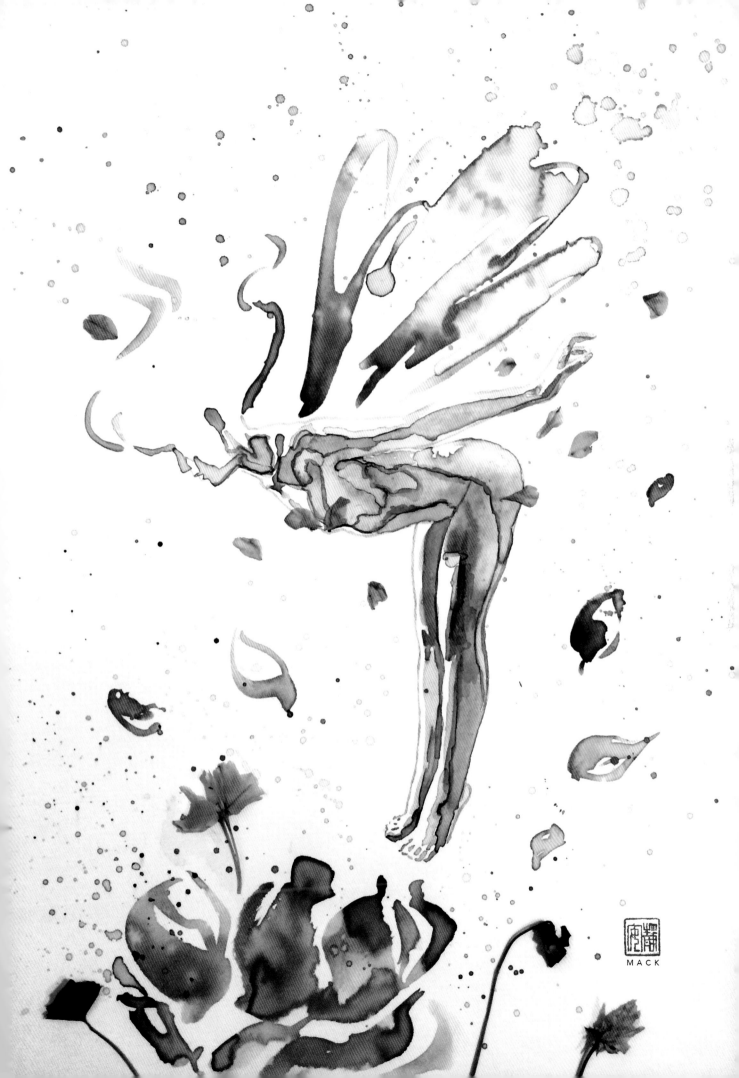

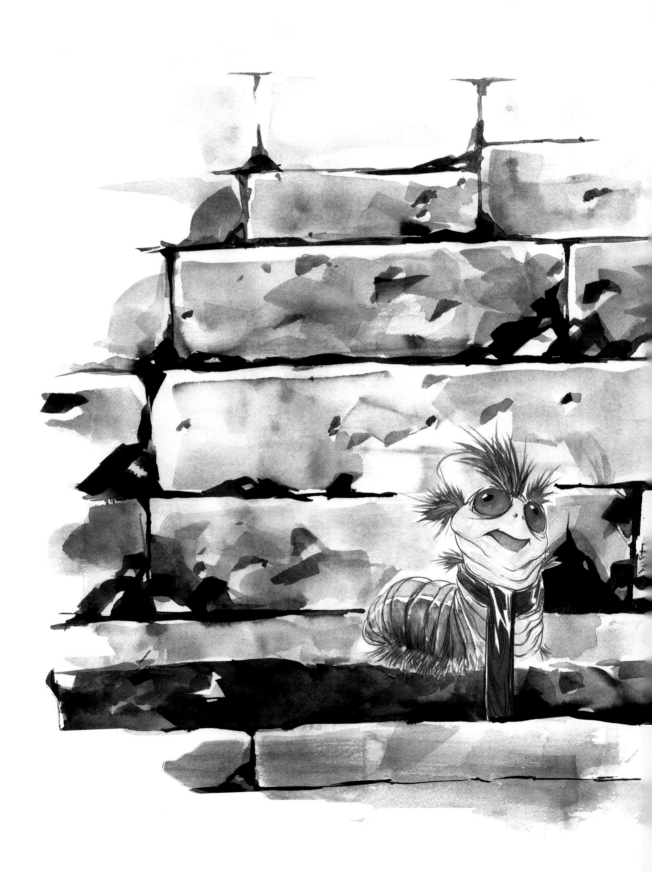

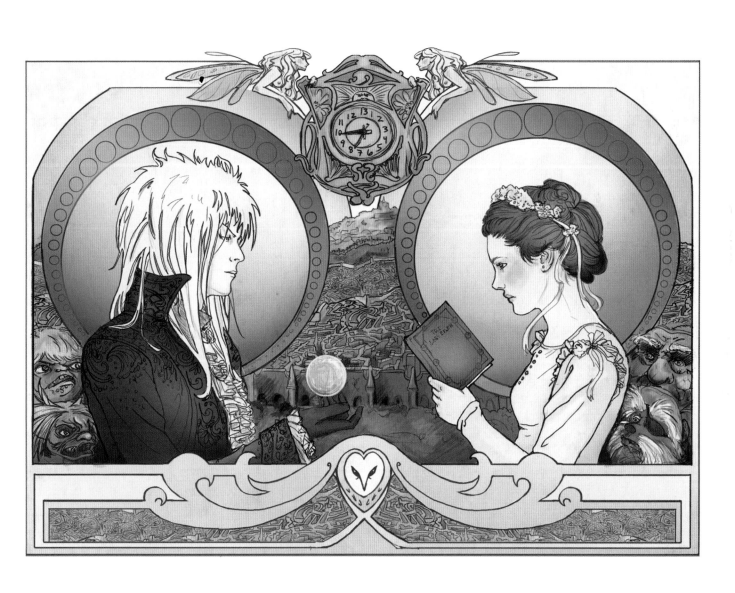

Facing Page: *Art by Dustin Nguyen*. Above: *Art by Jane Burson*. Following page: *Art by Jill Thompson*.

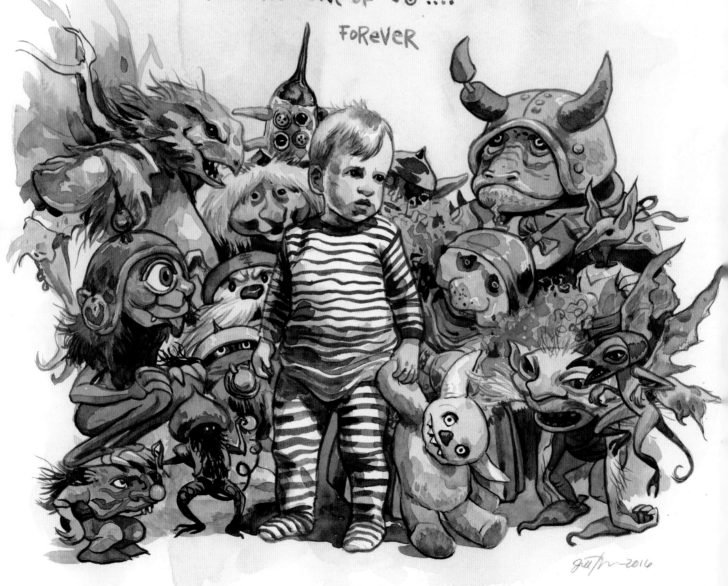

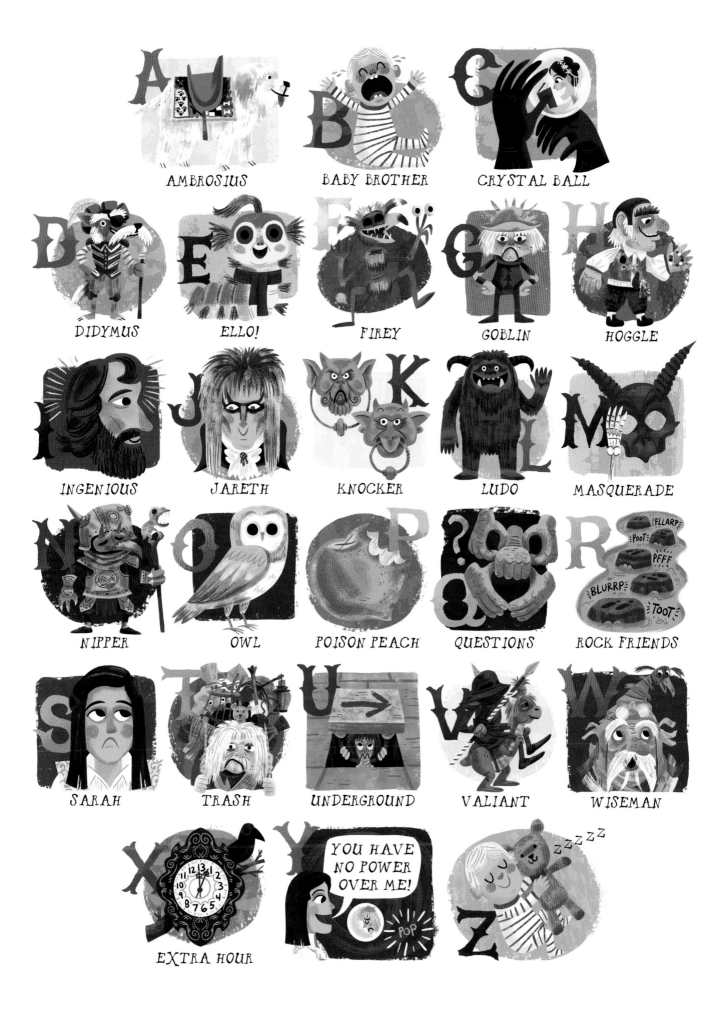

AMBROSIUS

BABY BROTHER

CRYSTAL BALL

DIDYMUS

ELLO!

FIREY

GOBLIN

HOGGLE

INGENIOUS

JARETH

KNOCKER

LUDO

MASQUERADE

NIPPER

OWL

POISON PEACH

QUESTIONS

ROCK FRIENDS

SARAH

TRASH

UNDERGROUND

VALIANT

WISEMAN

EXTRA HOUR

YOU HAVE
NO POWER
OVER ME!

Since the very first time I saw *The Muppet Show* and *Sesame Street* as a youngster, I was deeply connected to the clever storytelling, imaginative characters, and magical worlds they populated. That admiration for the artistry has continued to fuel me on my own creative journey as an illustrator, author, and dreamer. Jim Henson has been my lifelong creative hero not only because of the unique creativity he brought to this world, but also the joyful, fun-loving passion with which he pursued his dreams, and the way he inspired others to dream.

During Jim Henson's memorial service, Jocelyn Stevenson (a writer for The Jim Henson Company) related Jim's artistry to the stem of a dandelion, and everyone who was ever touched by his work were like dandelion seeds blown by the breeze of his legacy. I certainly consider myself to

it seems." I recall staring at that poster, getting as lost as Sarah in that world of characters. My love for that treasure trove of characters is what inspired this piece.

This piece was originally created for the Gallery 1988 (West) show "30 Years Later" that opened March 25, 2016. It wasn't difficult to choose a favorite film of 1986 for the show, but it was difficult to choose only twenty-six characters/elements from such a wildly imaginative and magical world. I wanted to challenge myself to tell the entire story with only the letters of the alphabet and echo the richness of the original movie poster.

It's a true joy to see my own three children sharing that same admiration and love for the entire collection of The Jim Henson Company films, shows, and books that I enjoyed

{ *Labyrinth* was one of the earliest films I can remember seeing in the theater, and it absolutely changed my idea of what was possible with puppetry and storytelling. }

be one of those seeds that has been deeply inspired by his creativity and desire to create work that is rich with cleverness, imagination, and heart.

Labyrinth was one of the earliest films I can remember seeing in the theater, and it absolutely changed my idea of what was possible with puppetry and storytelling. I had already been a fan of *The Muppets* films, *The Muppet Show*, and *Sesame Street*, but this new, wildly imaginative world of *Labyrinth* delivered just as the movie poster promised, "A world where everything seems possible and nothing is what

as a child, along with all the new work they continue to create today! That is the true magic of The Jim Henson Company's work: it continues to inspire new dreamers and creatives to carry on that legacy of storytelling no matter what aspect of it you connect with. It's truly an honor to be part of this tribute as a heartfelt thank you for all the inspiration Jim's work has been to me throughout my life.

Luke Flowers

Previous page: *Art by Luke Flowers*. Facing page: *Art by Aaron Renier*.
Following pages: *Art by Craig Thompson* (left) *and art by Jonas McCluggage* (right).

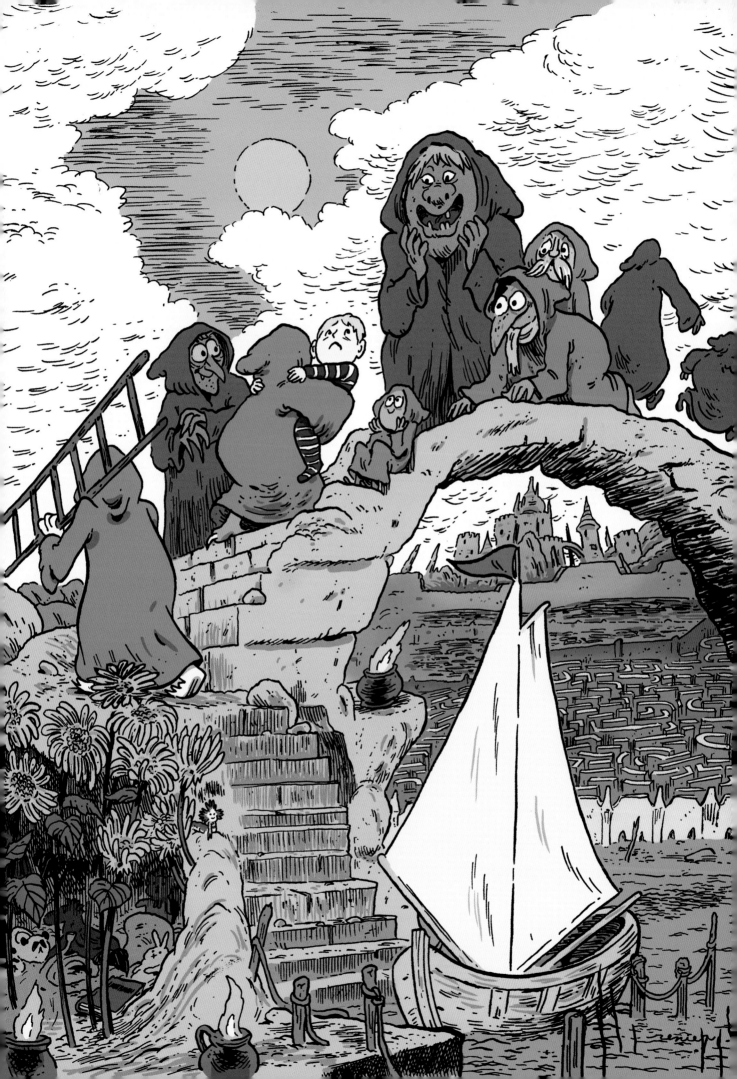

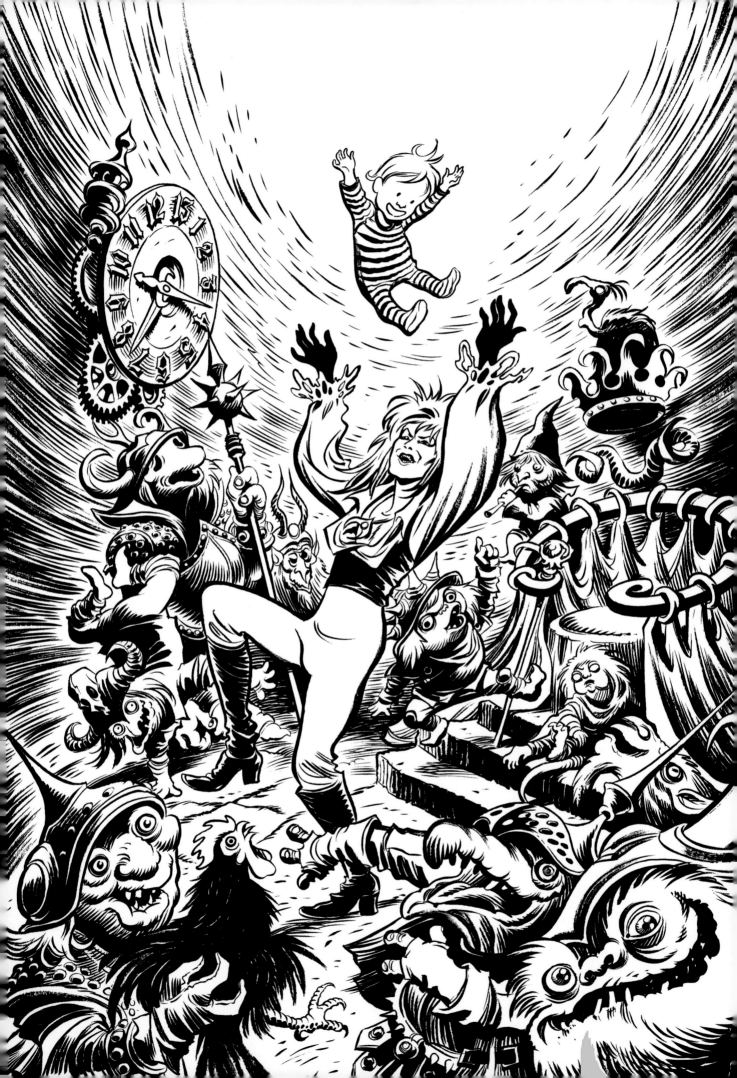

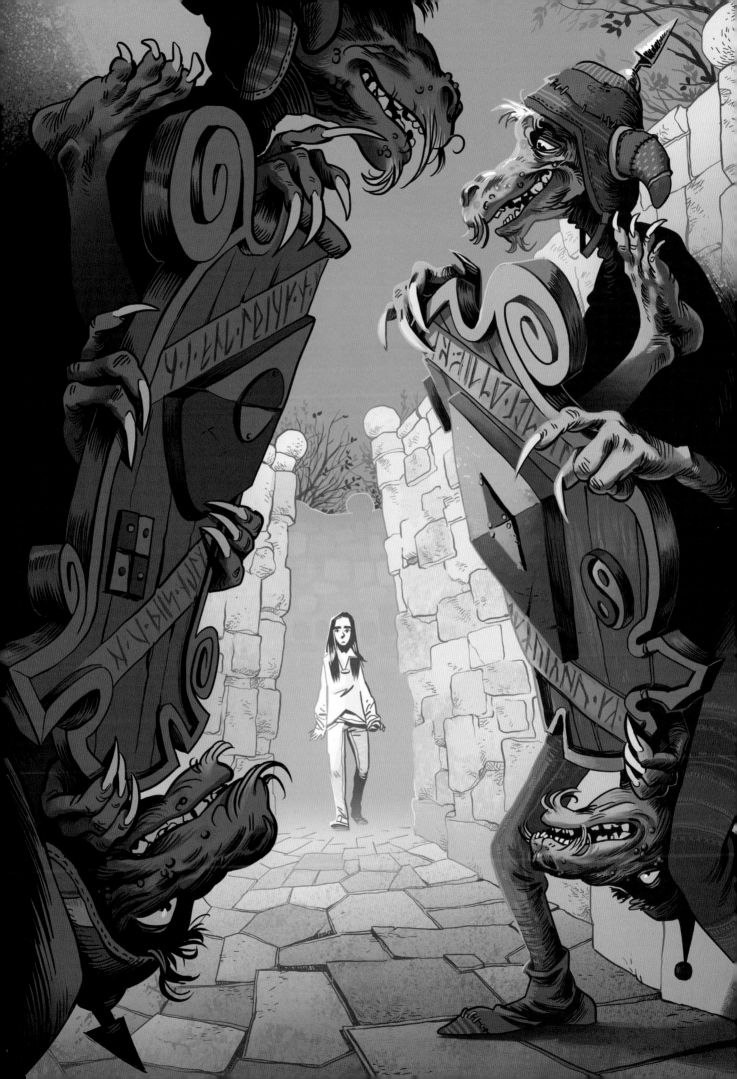

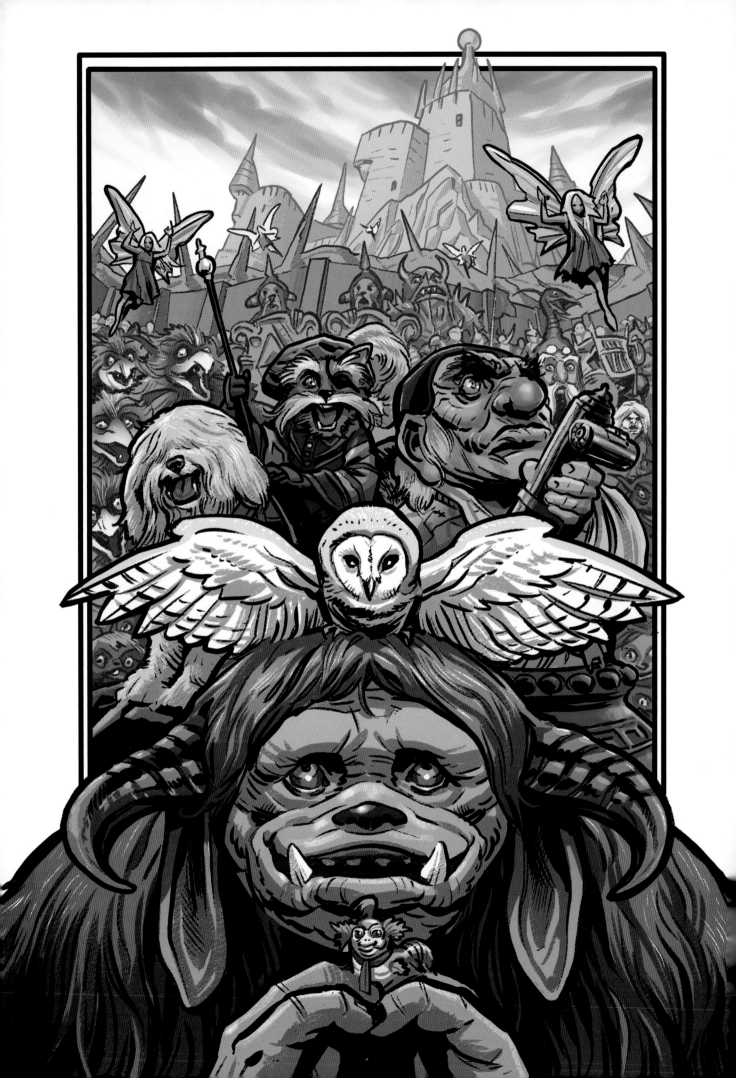

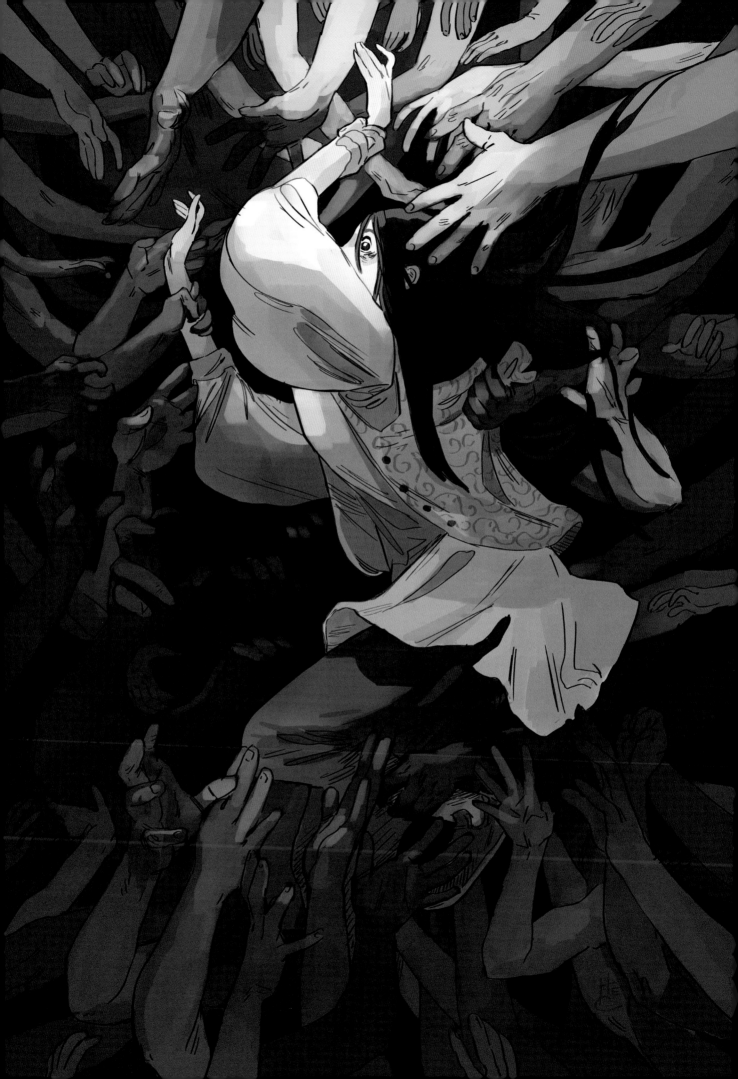

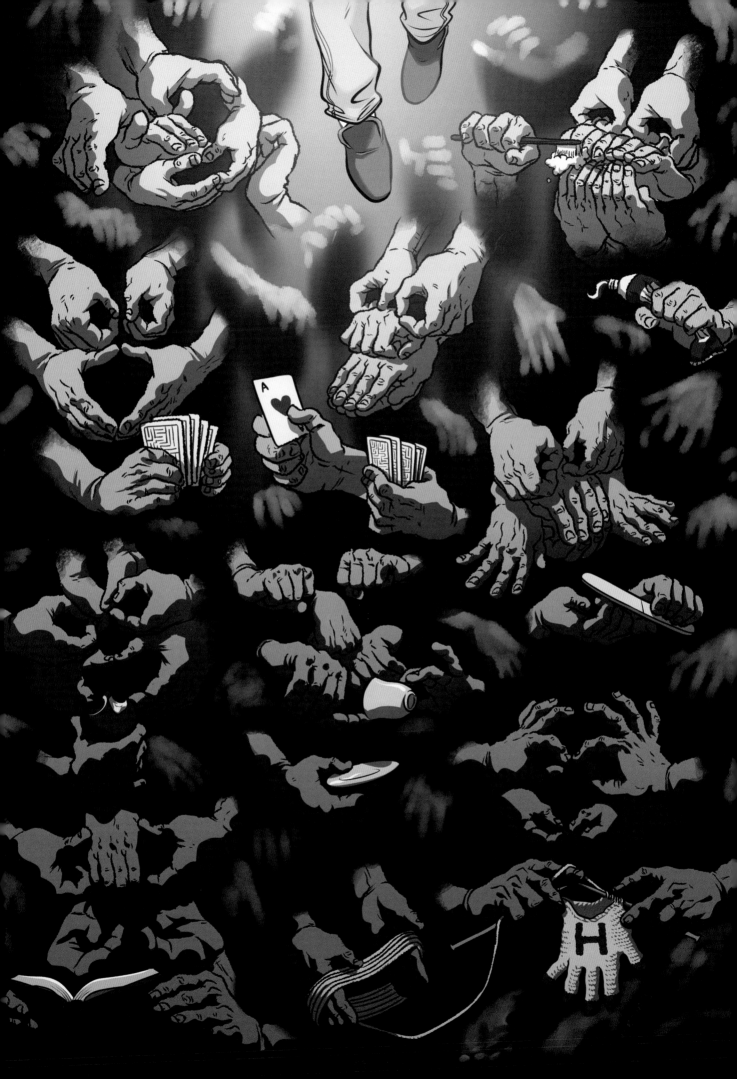

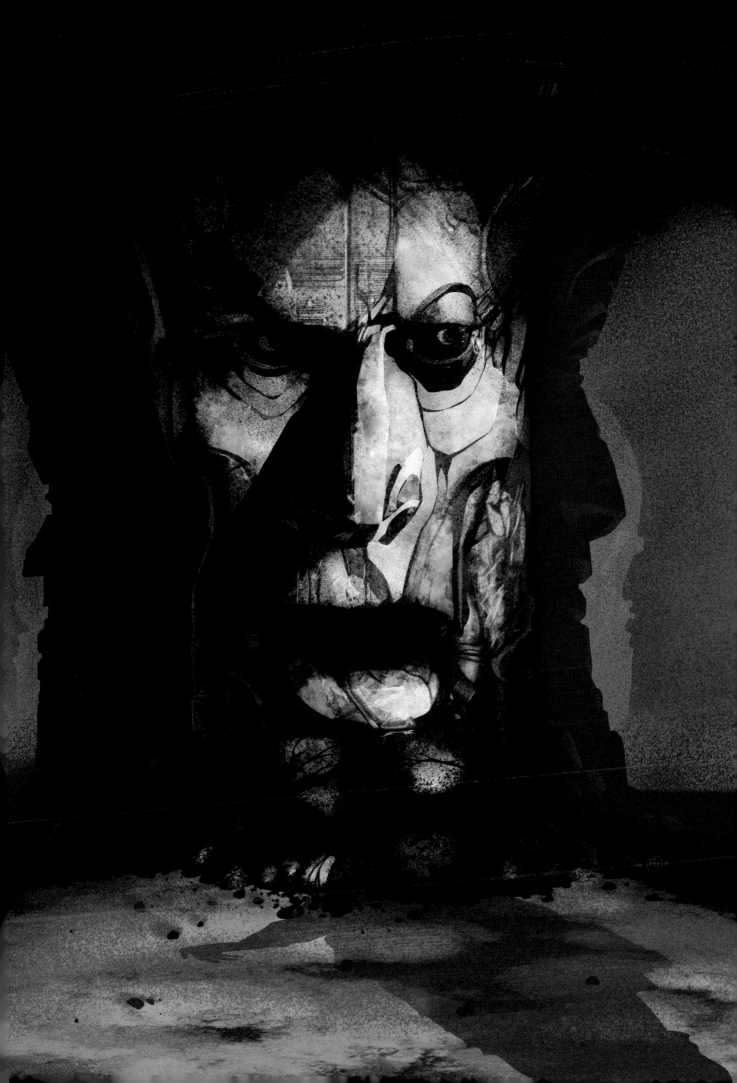

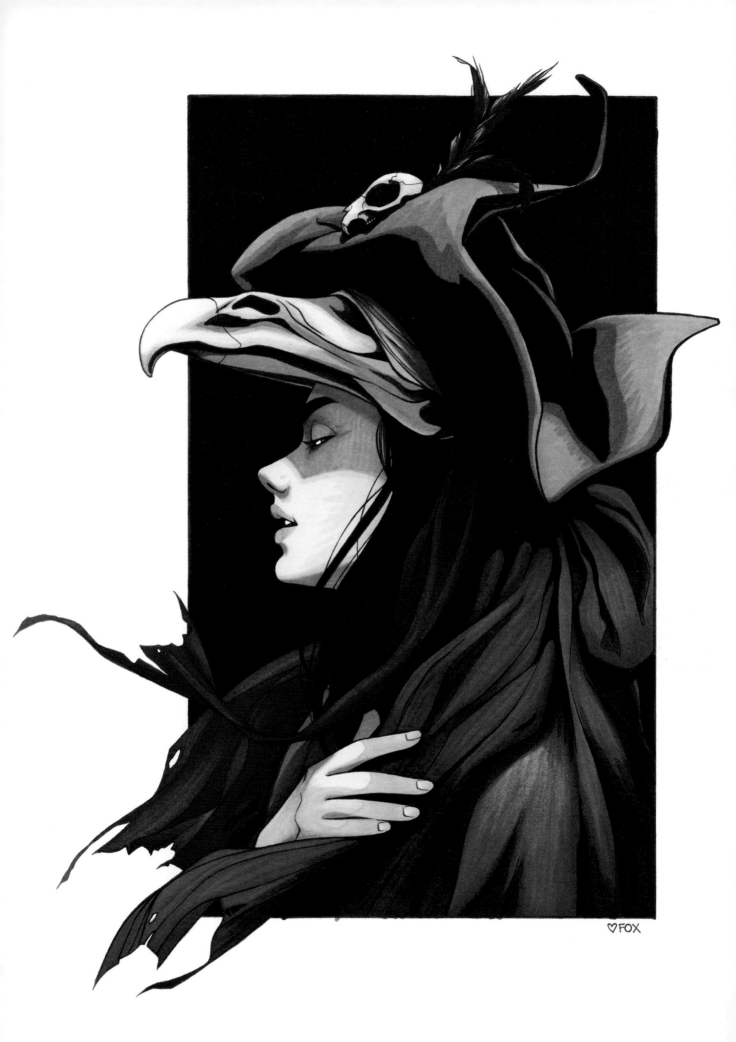

I first saw *Labyrinth* when I was twelve years old, and I fell instantly in love. It made me think that there were more magical things in the world than I could see. I thought it was my little secret for the longest time.

Lily Fox

Helping hands that become faces and speak to one another, the bog of eternal stench, a sweeping masquerade, a kind caterpillar, four guards who pop up from behind their shields, tiny goblins that charge from atop green lizards, and a wiseman who argues with the bird that is his hat . . .

{ **. . . a delightful tribute to imagination.** }

There are so many moments of sheer joy in this film that really do make *Labyrinth* such a delightful tribute to imagination.

Hayden Sherman

Page 24: *Art by Benjamin Dewey*. Page 25: *Art by Hannah Christensen*. Previous pages: *Art by Dylan Meconis* (left) and *Frazer Irving* (right). Facing page: *Art by Lily Fox*. Following pages: *Art by Hayden Sherman*.

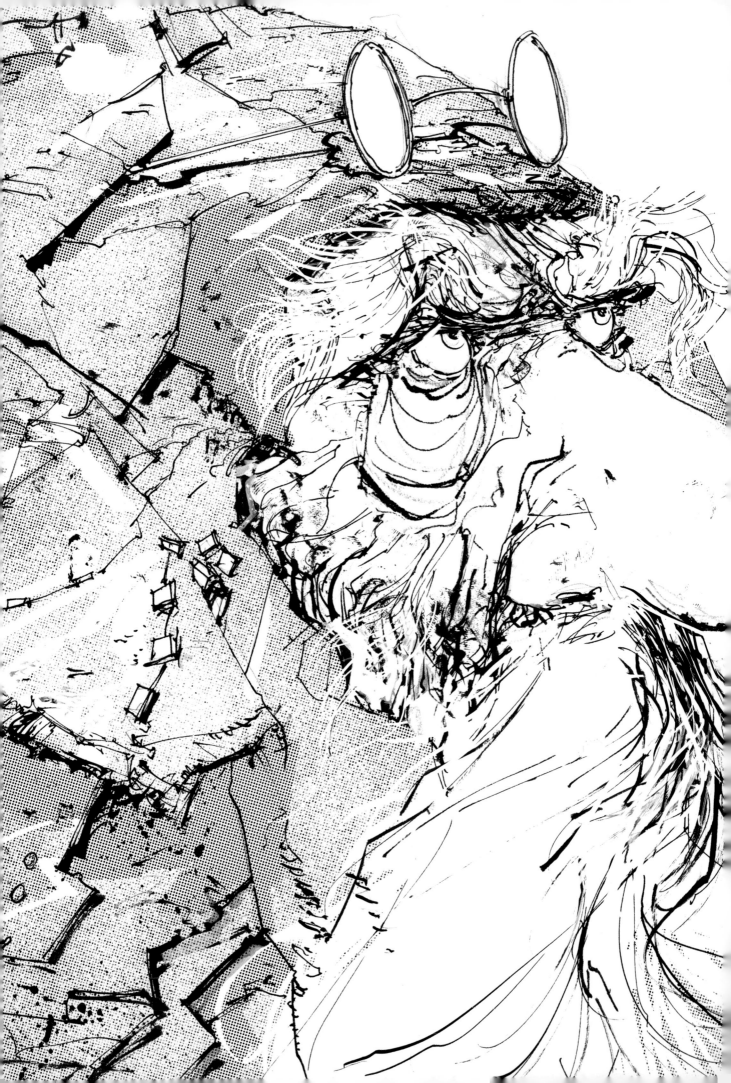

Perhaps, surprisingly (or, perhaps, shockingly), I didn't see *Labyrinth* until I was in my mid-twenties. I was about the right age for it but, growing up, I was only interested in animation. If it was live action, little Cory just couldn't be bothered. Undoubtedly, my first brush with *Labyrinth* must've been through the *Muppet Babies* episode (animation, you see).

I love Brian Froud's work and he, especially, has been an inspiration to me. In fact, I believe that we share many of the same historical artistic influences and that's helped me to understand the complex visual language which was developed for the film.

{ **I love Brian Froud's work and he has been an inspiration to me.** }

I take all of my *Labyrinth* related work very seriously and I work hard to be certain that I've gathered appropriate reference for the characters and the world itself. I'm always seeking to approach it respectfully. At the same time, I can't help but bring my own style and essence to the work and will avoid leaning *too* heavily on the reference.

Ultimately, I feel incredibly grateful that I've been given the opportunity to put my thumbprint on the world of *Labyrinth* and, in some small measure, add to the Henson legacy.

Cory Godbey

Facing page: *Art by Cory Godbey.* Following pages: *Art by I.N.J. Culbard* (left) *and art by Max Dalton* (right).

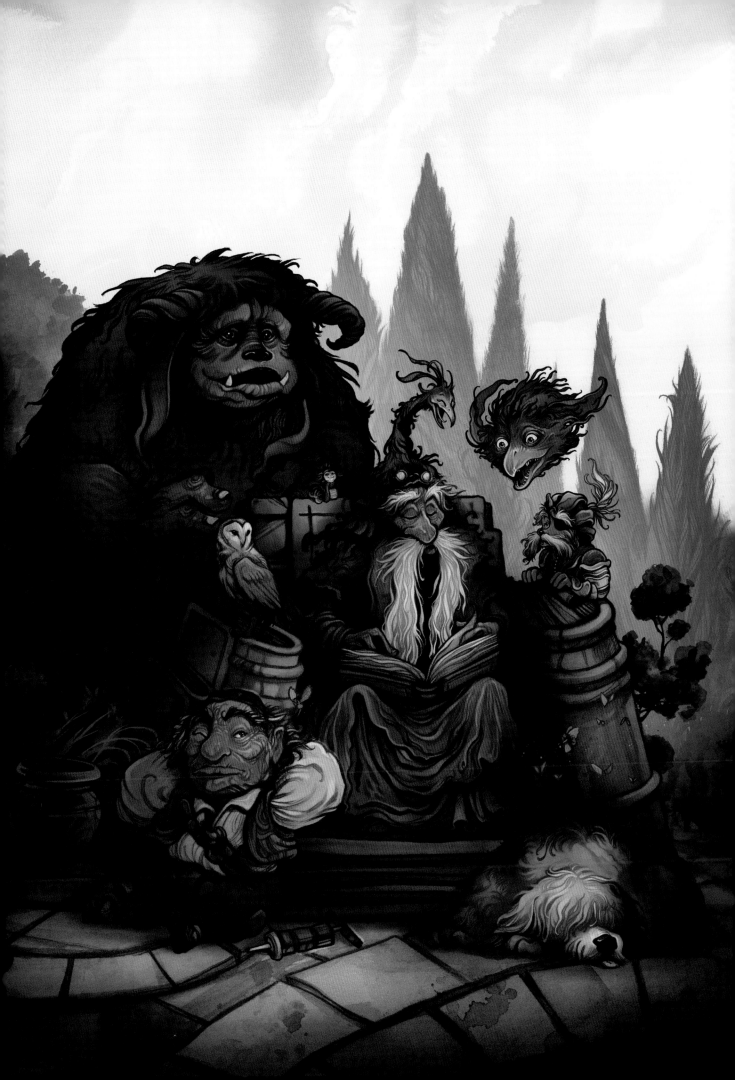

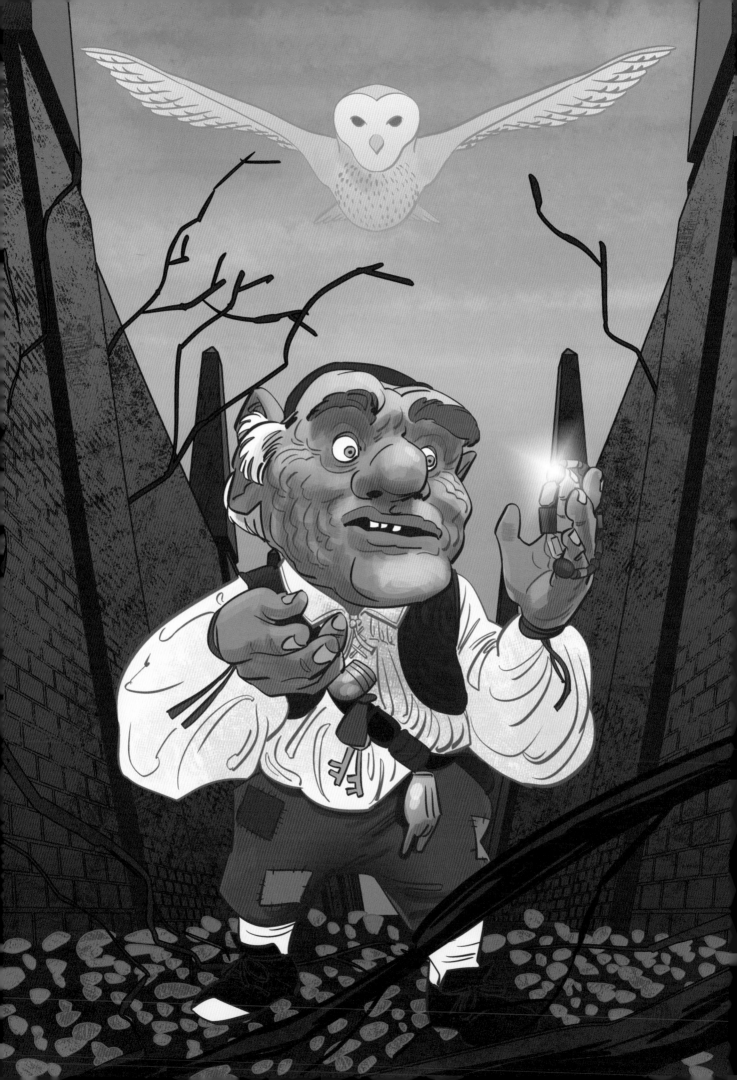

LABYRINTH

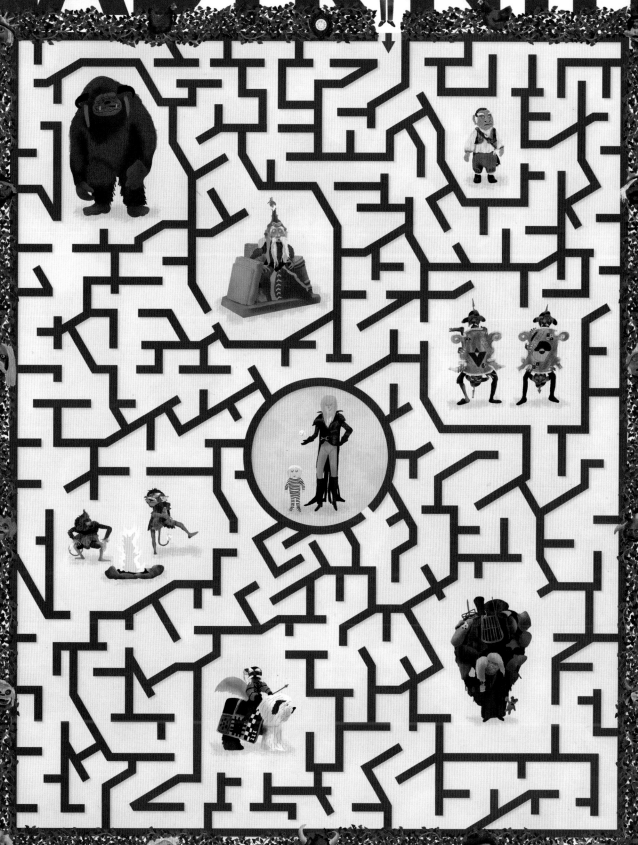

I'm a lifelong fan of both Jim Henson and Brian Froud, and have had the amazing opportunity to correspond with both of my creative heroes—in my youth and my adulthood. So getting to play in this world they created is a childhood dream fulfilled, and a professional privilege that I truly treasure.

As a child, watching *Sesame Street*, *The Muppet Show*, and even *The Land of Gorch* sketches on *Saturday Night Live*, Jim shaped my appreciation of monsters, my view of what they could be, and the kinds of stories and humor they could convey. At that same time, I was reading Brian Froud's co-authored book *Faeries* (with Dennis Lee), which showed me a darker, more organic, but no less fun school of monster design that inspired me just as passionately. So choosing this particular scene to draw, which showed monsters wielding monsters to attack a monster, was a trifecta of subject matter perfection for me.

Ludo's introduction scene in *Labyrinth* is a wonderful amalgam of peril, comedy, and even a hint of horror, so drawing it took a careful touch so as not to tip that balance. My initial sketch for this piece just had Ludo being attacked by the goblins, which seemed almost cruel out of context. So I chose to include Sarah, wielding Ludo's rock friends, which gave the situation hope for this lovable beast.

When drawing popular characters, I have a tendency to draw stylized cartoon versions of them. But the reverence I have for *Labyrinth* dictated as faithful an interpretation as I could muster. I took particular joy in drawing the armored goblins, with their vaguely harlequin face plates and their living, carnivorous lances. I scrutinized my DVD of the movie frame by frame as I sketched, hoping to get every little rivet, scrap of cloth, and chink of chain mail into my renditions. Being a follower of animation, I did my best to create poses for the goblins that would show a lot of movement and expression while still being faithful to the scene's action. My one concession was drawing a goblin hanging from Ludo's tail—not something that happened in the film, but it seemed like a funny bit that would fit the tone of *Labyrinth*.

> **{ . . . getting to play in this world they created is a childhood dream fulfilled . . . }**

Labyrinth was the film Jim was working on when I first wrote to him at age eleven, and was released just months after Jim personally wrote me back. As such, it became one of my favorite films due to its creative merits and inspiration, and due to its significance in my connecting with my hero. I've always felt a strong appreciation for Jim Henson and his creations, and crafting this piece of artwork for this collection makes that appreciation more powerful and vibrant than ever.

Jay Fosgitt

Facing page: *Art by Jay Fosgitt*. Following pages: *Art by Jonathan Case*.

36

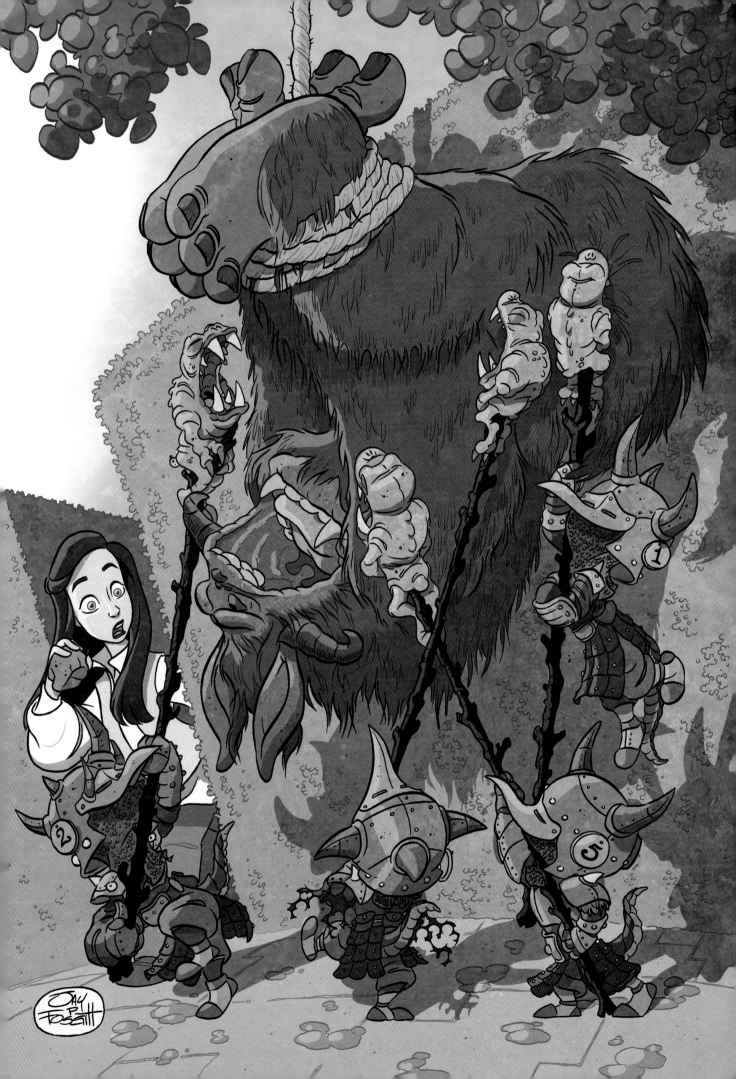

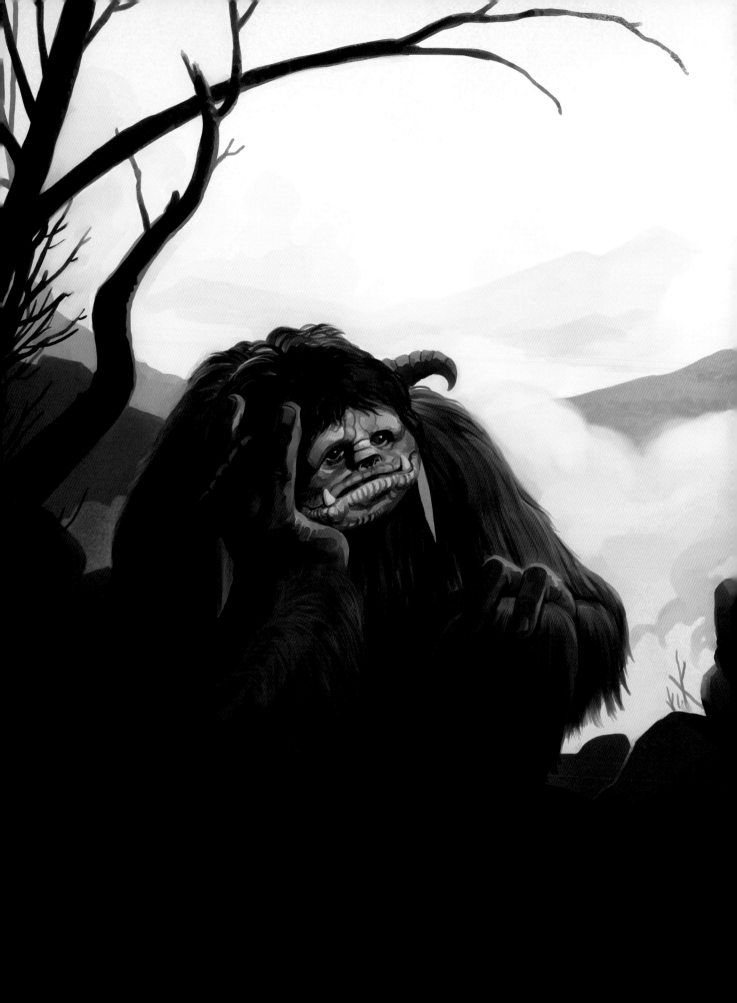

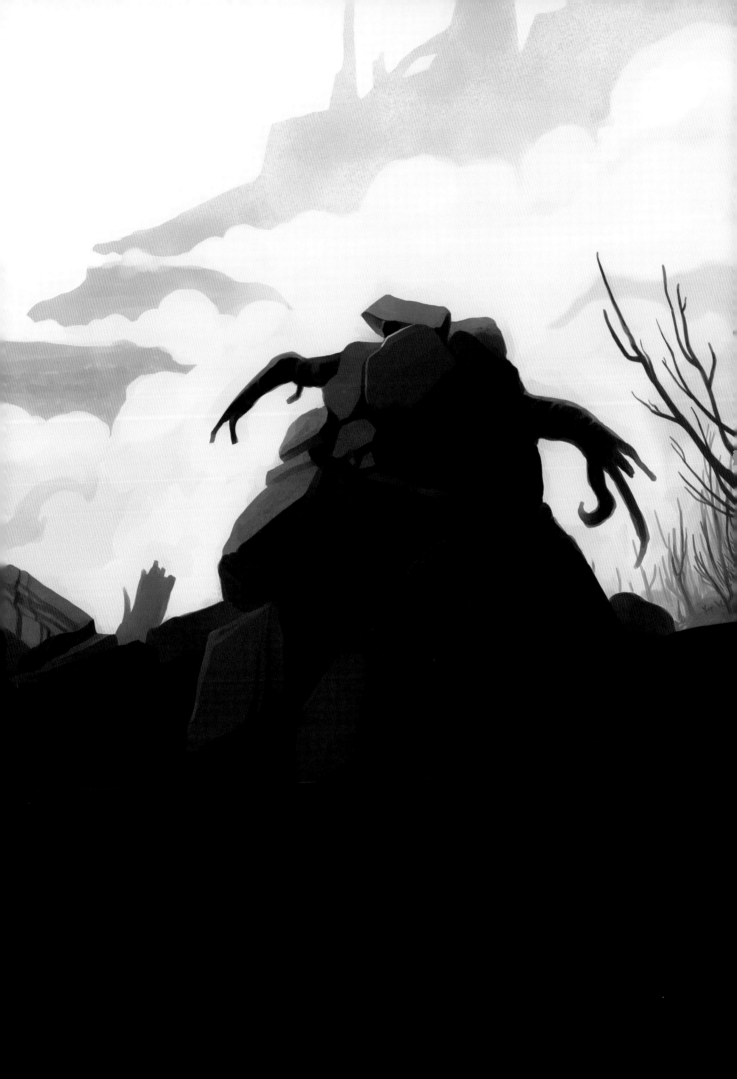

What struck me as a kid, when I first saw *Labyrinth*, was how grotesquely beautiful everything was. Every creature and set was made by hand and every object had

{ ... the movie frightened and delighted me ... }

a personality all its own. Without relying on pyrotechnics and CGI, this movie frightened and delighted me and also taught me harsh lessons about judging things at face value.

Joëlle Jones

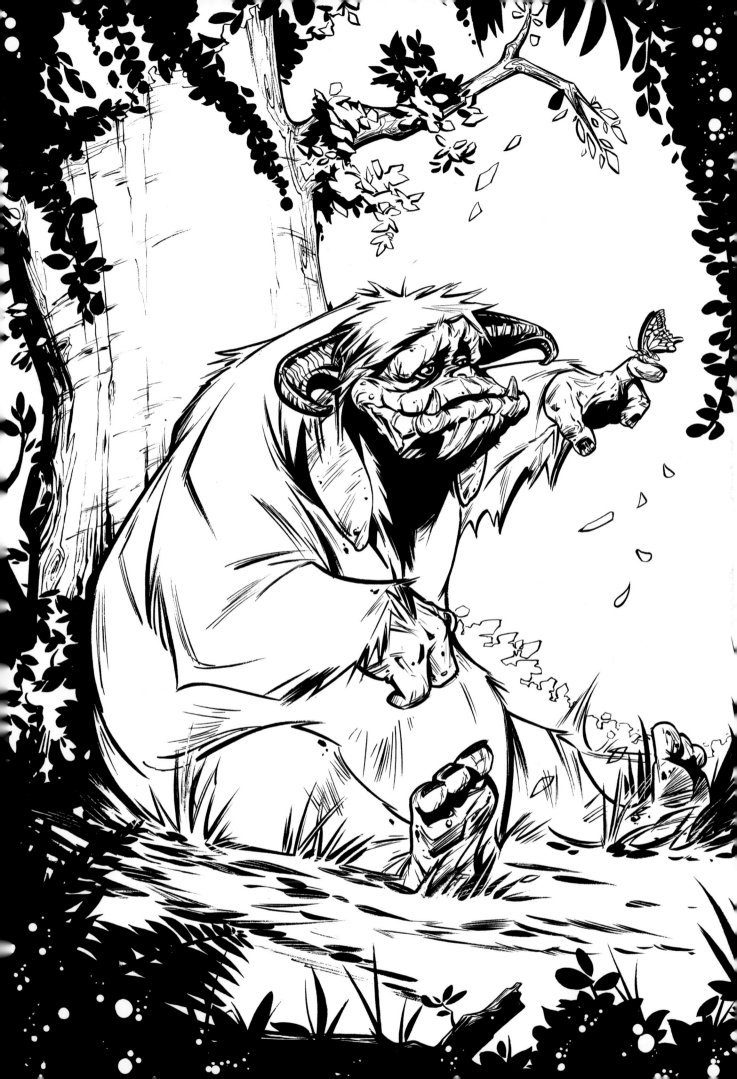

Labyrinth was among the most watched movies of my fifteenth orbit around the sun. I was utterly besotted with the protagonist, who was but a year older than I was so, psychologically, she was already waaaay out of my league anyway. And then Bowie shows up, crushing my dreams.

{ **I was utterly besotted with the protagonist . . .** }

And I watched it over and over again that year, along with that '60s Batman movie and some Duran Duran music videos. So I can lay partial blame at the foot of this movie for me eventually becoming an illustrator who pays artistic pilgrimage to one of its formative influences. You are what you eat, so they say . . .

Frazer Irving

Facing page: *Art by Alex Sheikman.*

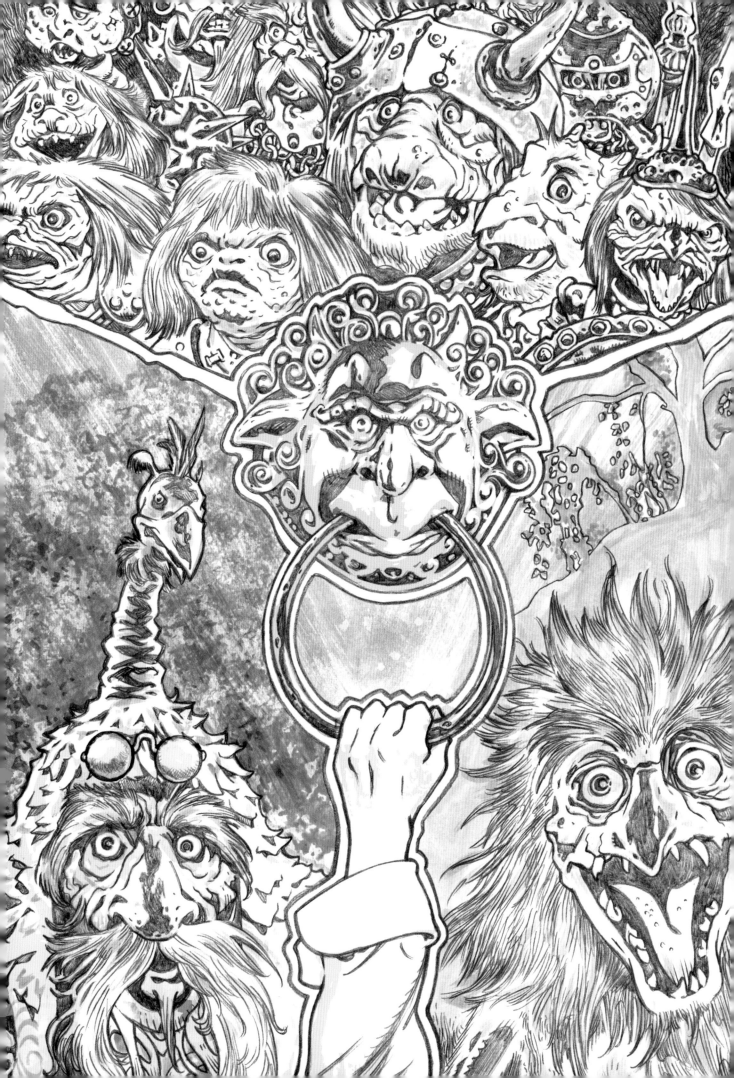

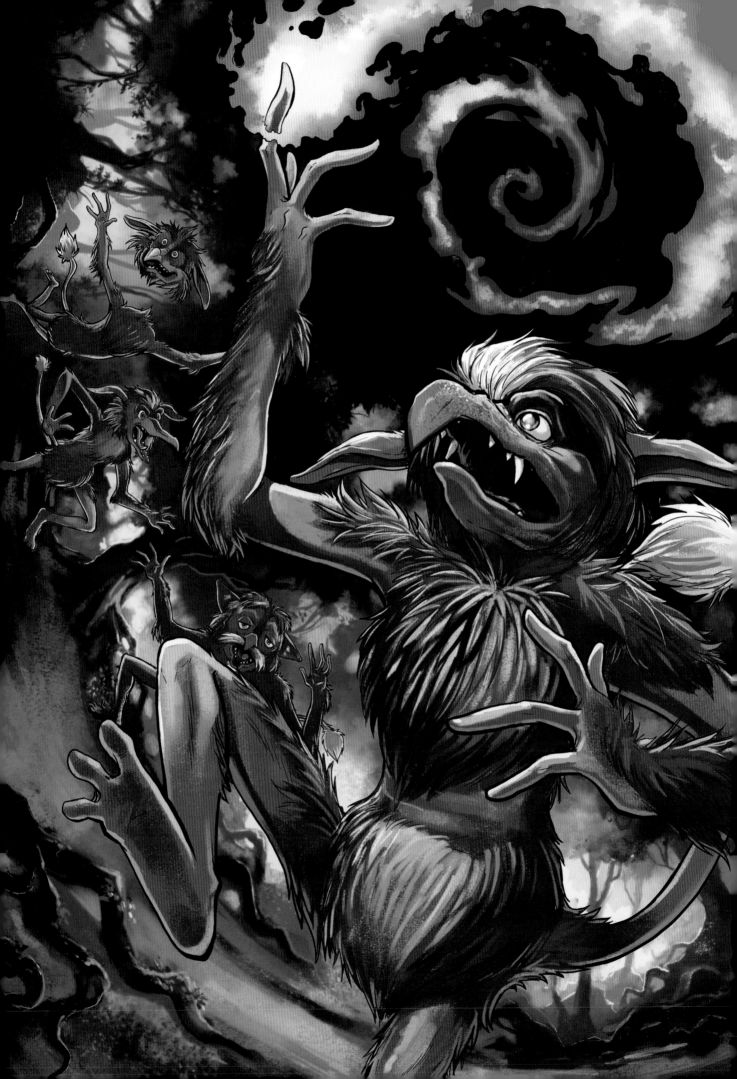

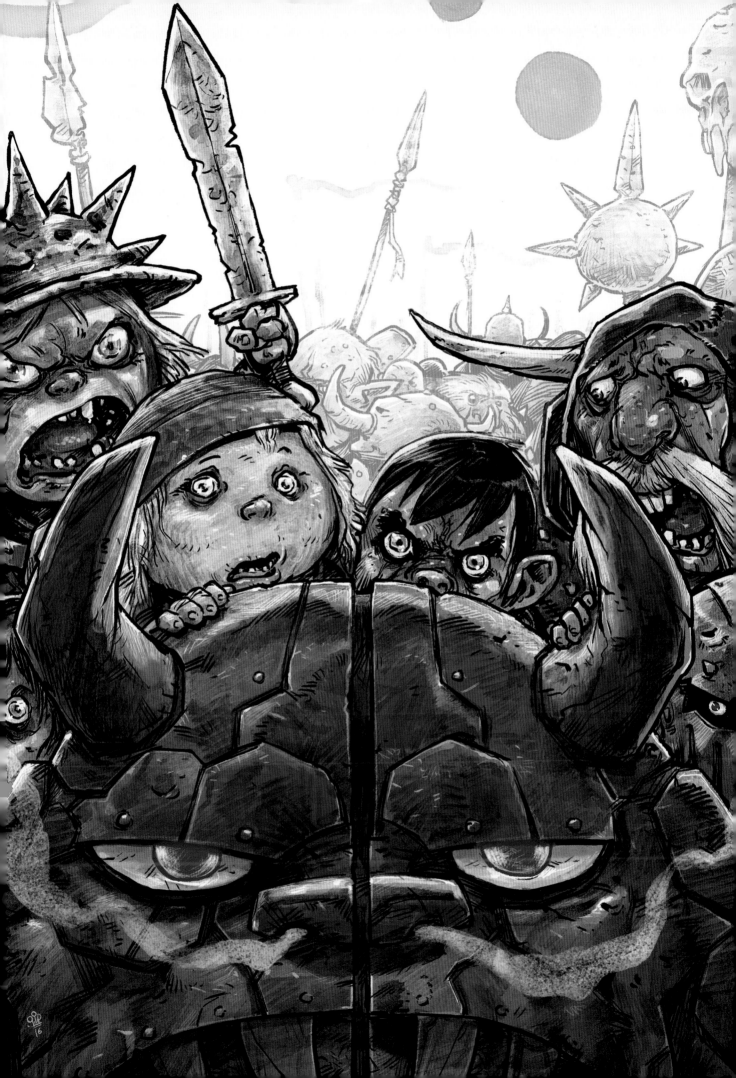

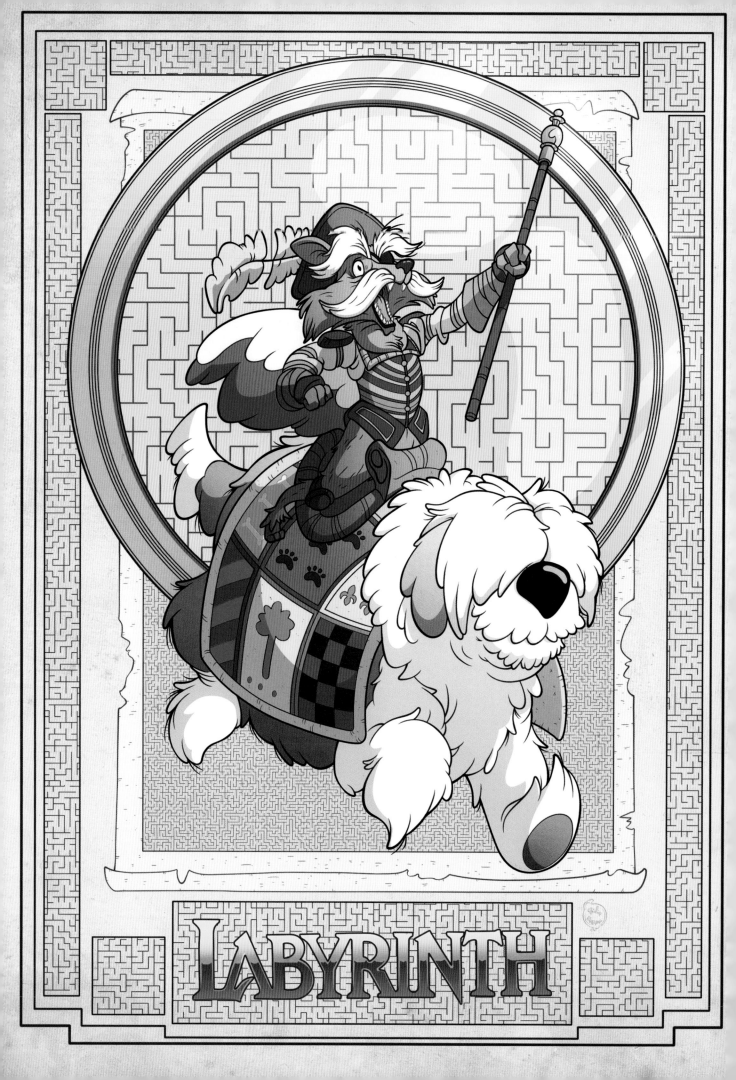

LABYRINTH

Ludo stood out with so much life. He was far beyond any character I could remember seeing as a child, and there was never any doubt that he was real.

Ian Herring

Over the years, Jim Henson has created some of the most memorable characters and worlds ever put to film. From *The Muppets* to *The Dark Crystal*, to a big yellow bird living on a very familiar street, he has shaped so many childhoods, including mine, in a very special way.

{ ... [Henson] has shaped so many childhoods ... }

With *Labyrinth*, Jim Henson and Brian Froud teamed up once again to breathe life into another fantastical world with memorable characters, this time with songs by the legendary David Bowie, and it truly is a lightning in a bottle movie that can never be replicated.

Phil Murphy

Previous pages: *Art by Jake Myler* (left) *and art by Michael Dialynas* (right). Facing page: *Art by Phil Murphy.* Following pages: *Art by Ian Herring.*

47

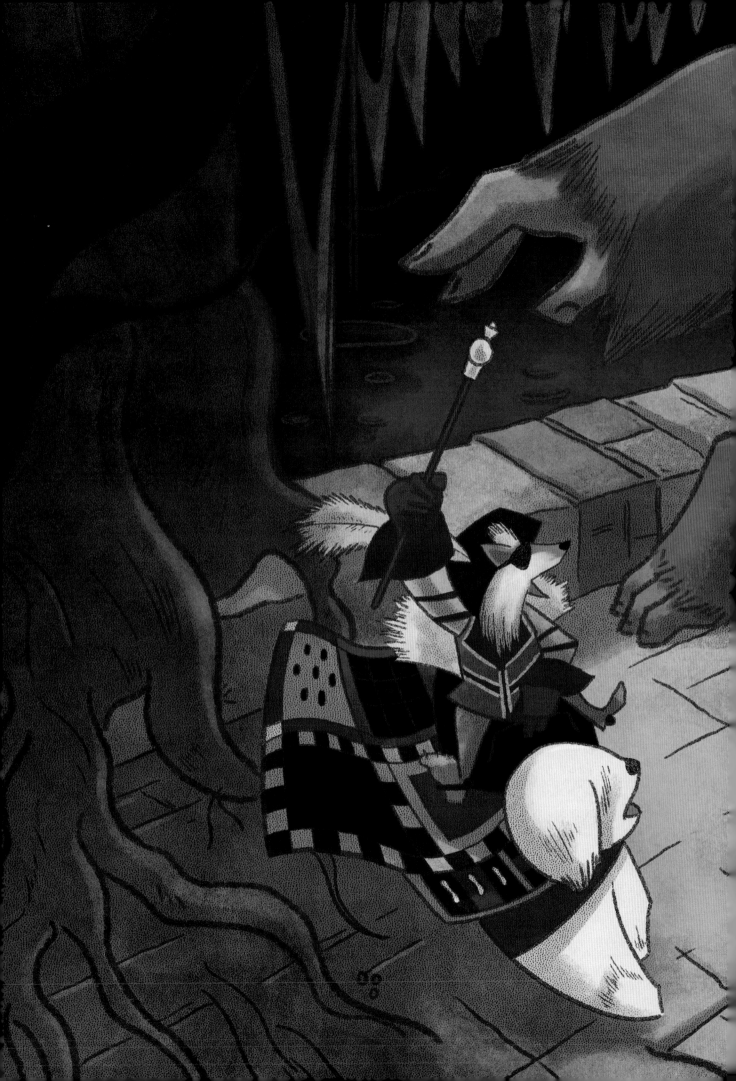

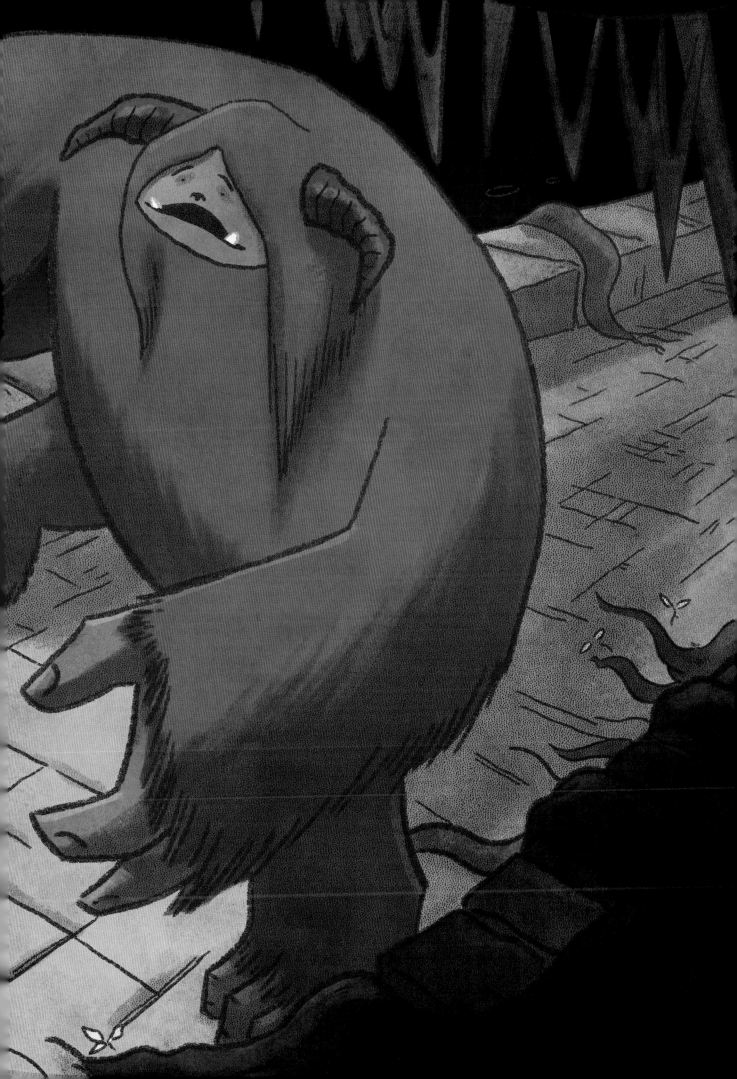

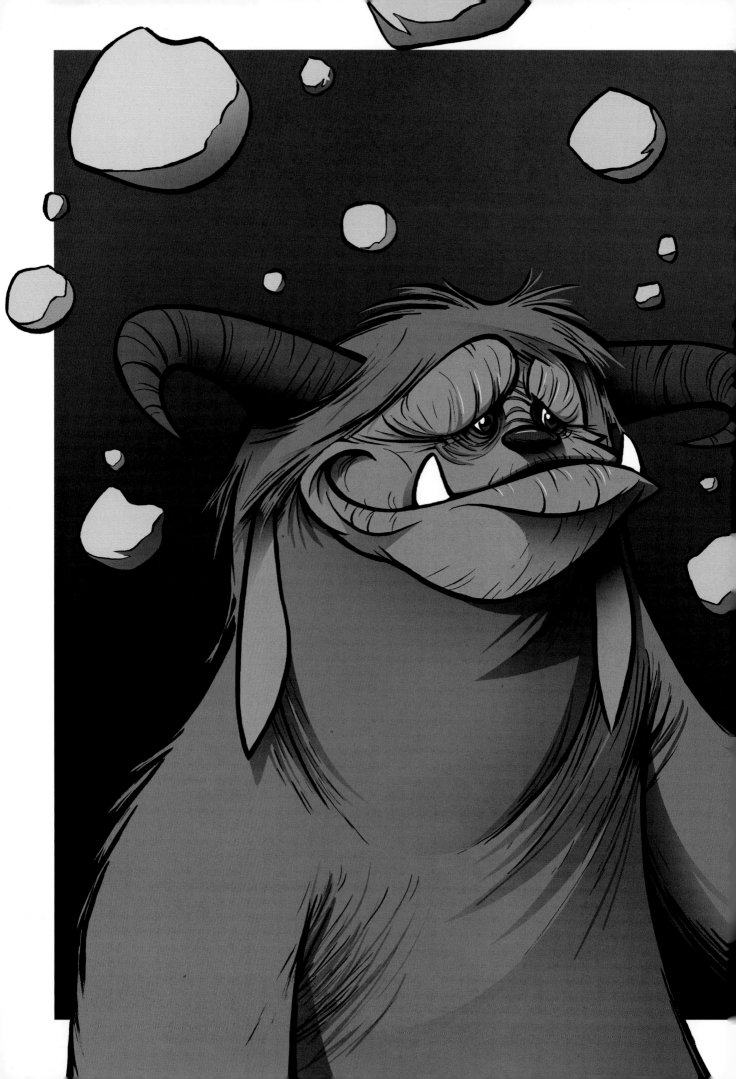

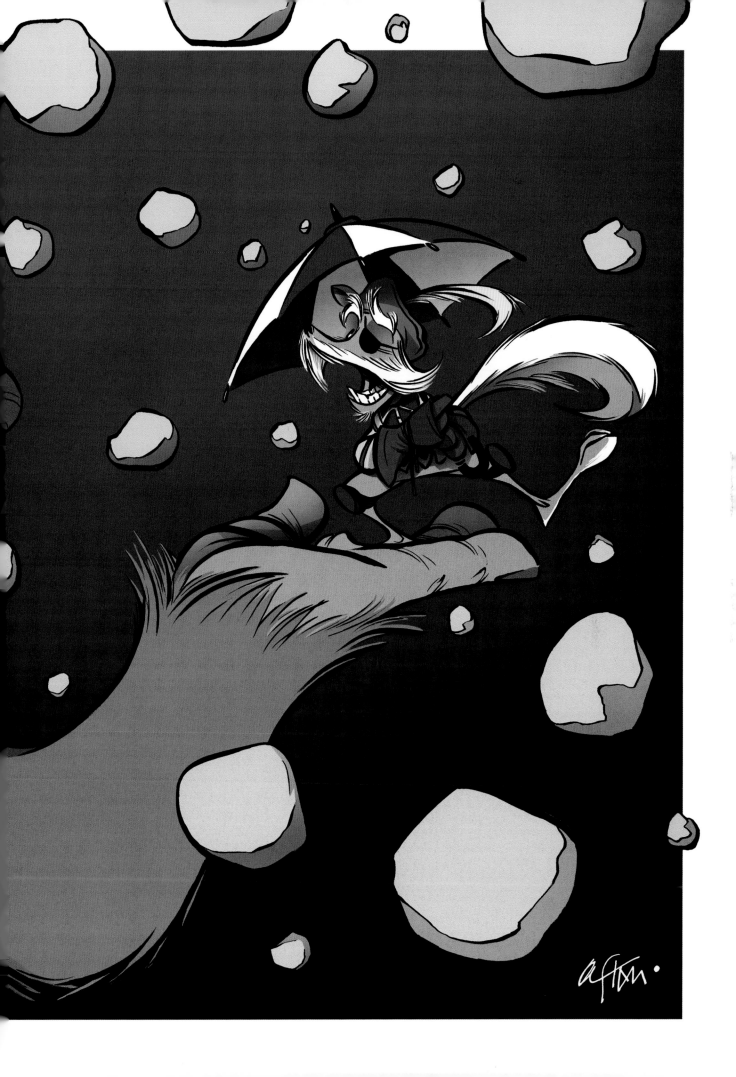

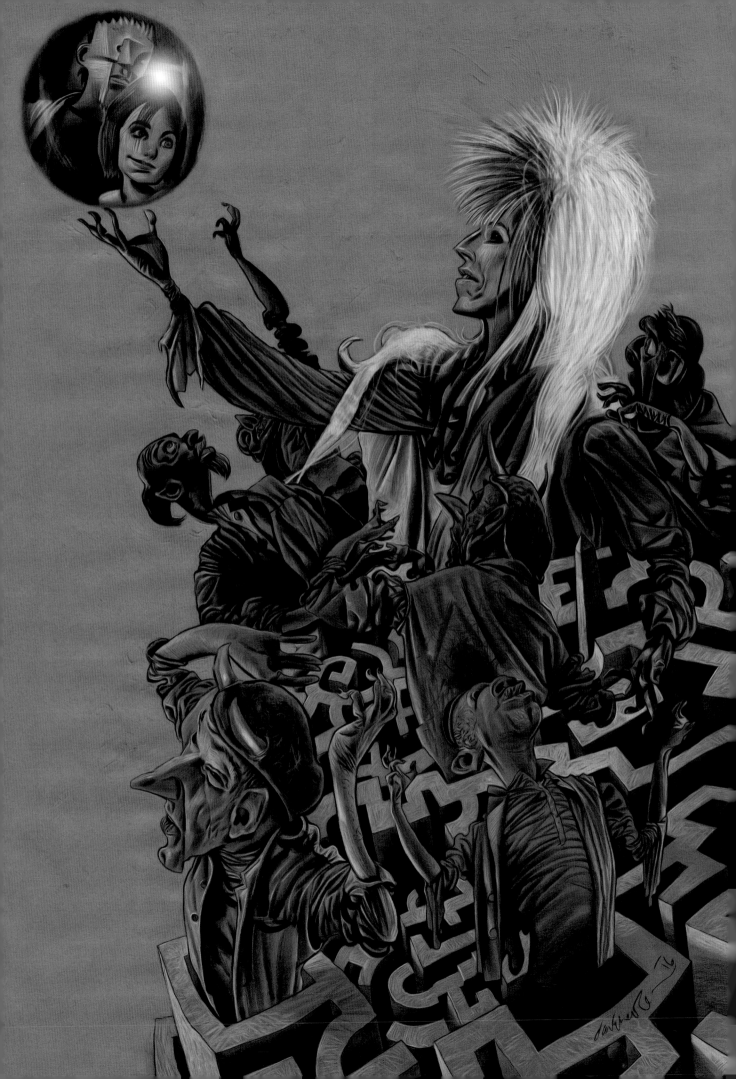

Jim Henson is one of the most important people of the 20th century. He was a player who really changed the game. That's a fact, not an opinion. Everyone knows it.

But for me, he is a little more than that. He is an idol and one of my greatest influences since I was a kid. He and his all-star team created an incredible range of classic characters, stories, and worlds that I was amazed by as a viewer and also as a professional cartoonist. The puppeteers take something simple, like a sock, and transform it into a much better character than a lot of flesh-and-blood actors that I know.

> { . . . [Henson] was a player who really changed the game. }

Unfortunately, I will never have the chance to meet Mr. Henson. But having the chance to work with his characters, I can now say that I am much closer to him. And it is a joy and a great honor.

Gustavo Duarte

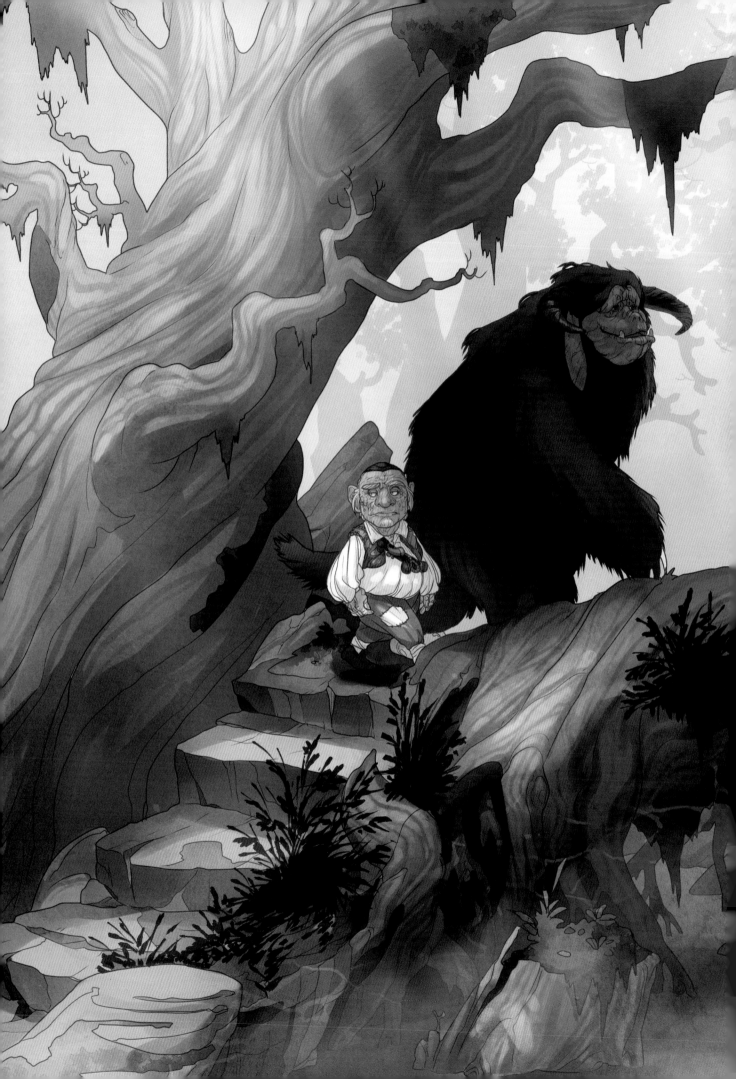

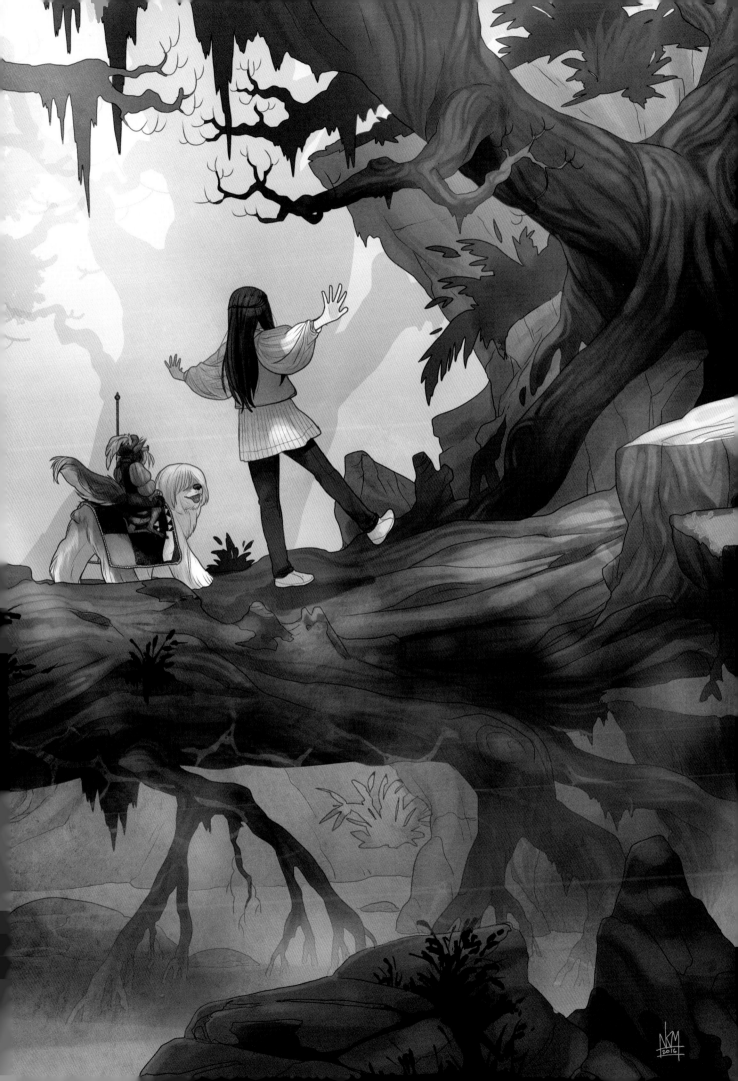

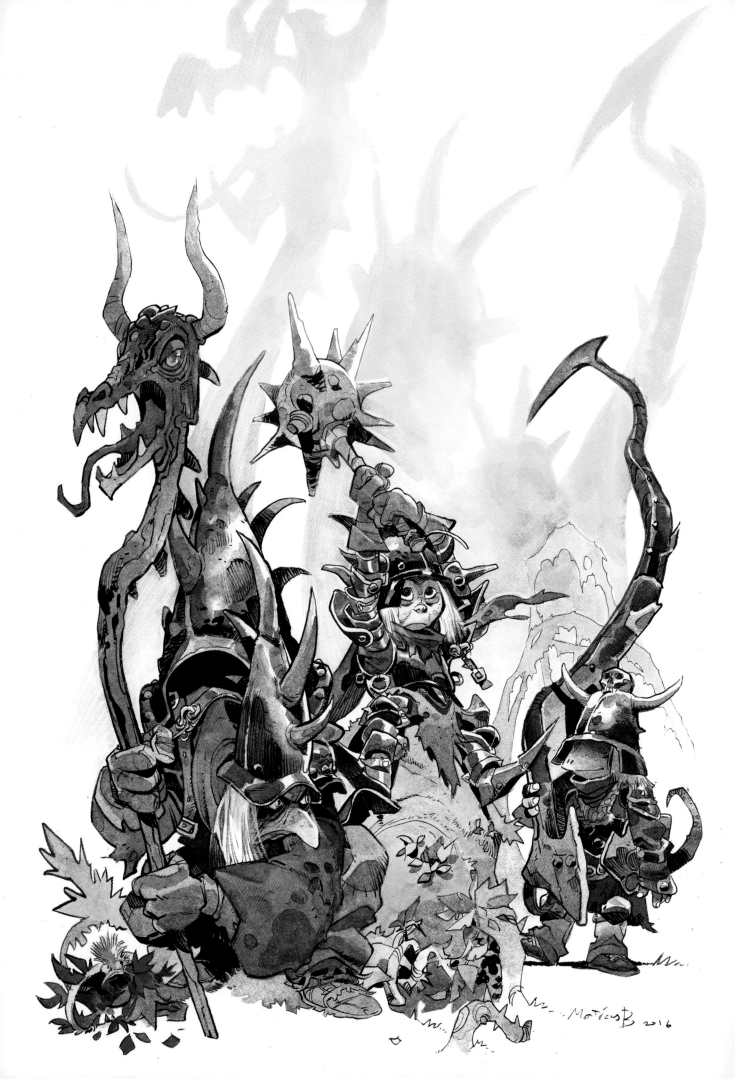

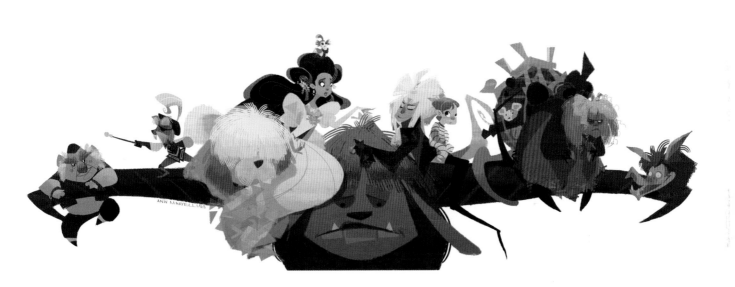

Previous pages: *Art by Kelly and Nichole Matthews.* Facing page: *Art by Matías Bergara.* Above: *Art by Ann Marcellino.*

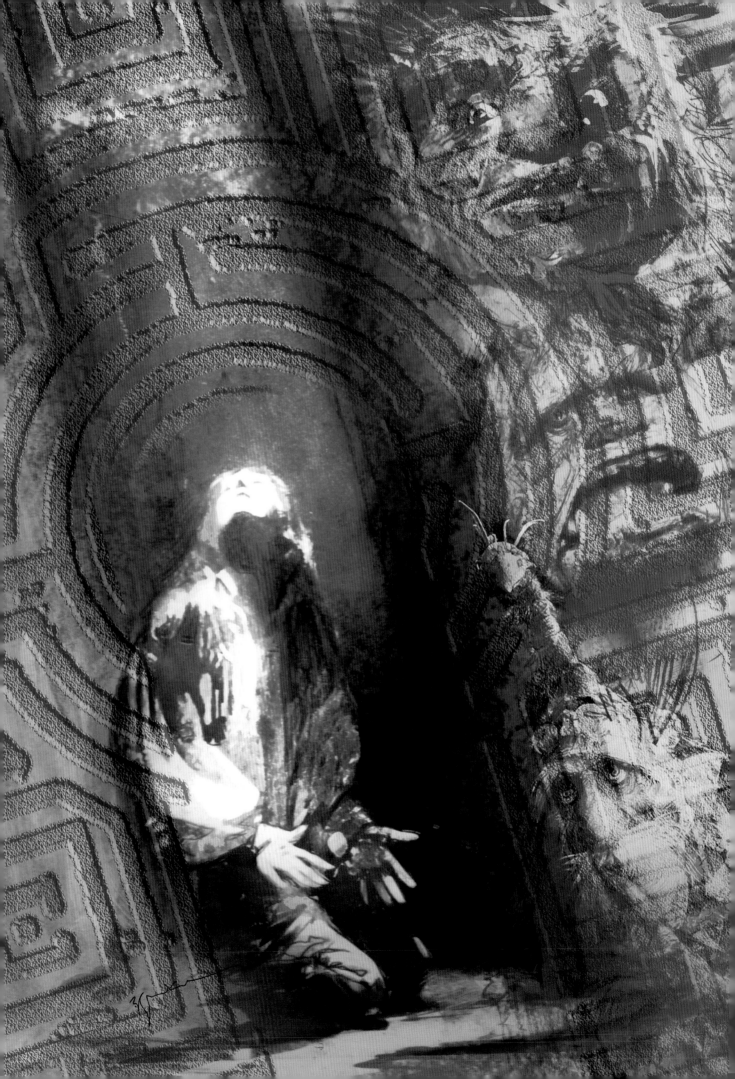

Whenever I go back to visit my mother's house, I lay down in bed and I look up to see the amazing *Labyrinth* poster that my sister bought a number of years ago. I can't remember if we owned a VHS of it or not, or if we just rented it from the Easy Video in Parsipanny, back when it used to be an Easy Video (I don't know what it is now).

Henson's work is just a part of the DNA of my childhood; it's one of the things that I vividly remember. From *The Muppets* to *Fraggle Rock* to *The Dark Crystal*, my sisters and I were always devouring one of his creations. *Labyrinth* always stuck out to me, though, which is something considering Henson's oeuvre. The music, for one, is just so playful and memorable because Bowie is, of course, unchallengeable in that role. But I think it's that *Labyrinth* feels like it's existed there forever, and that it exists even now. I think that's the genius of Henson and Froud and why *Labyrinth* has lost nothing in the years since its release. It's not just that the creature design is masterful, or that the actors are charming, it's that the focus was always building an exciting visual language and story. We've seen how special effects can age. What once was stunning, may now underwhelm. But when you build a world from the ground up, everything just feels like it's in its right place.

{ **Henson's work is just a part of the DNA of my childhood . . .** }

So it's hard to really qualify what *Labyrinth* means, but I still look to it and other Henson and Froud projects as a guidebook for my own stories. To tell the stories I want to tell, and make sure that I'm building them from the ground up, with all the care in the world, so people will still care for them long after the Easy Video's of the world move on.

S.M. Vidaurri

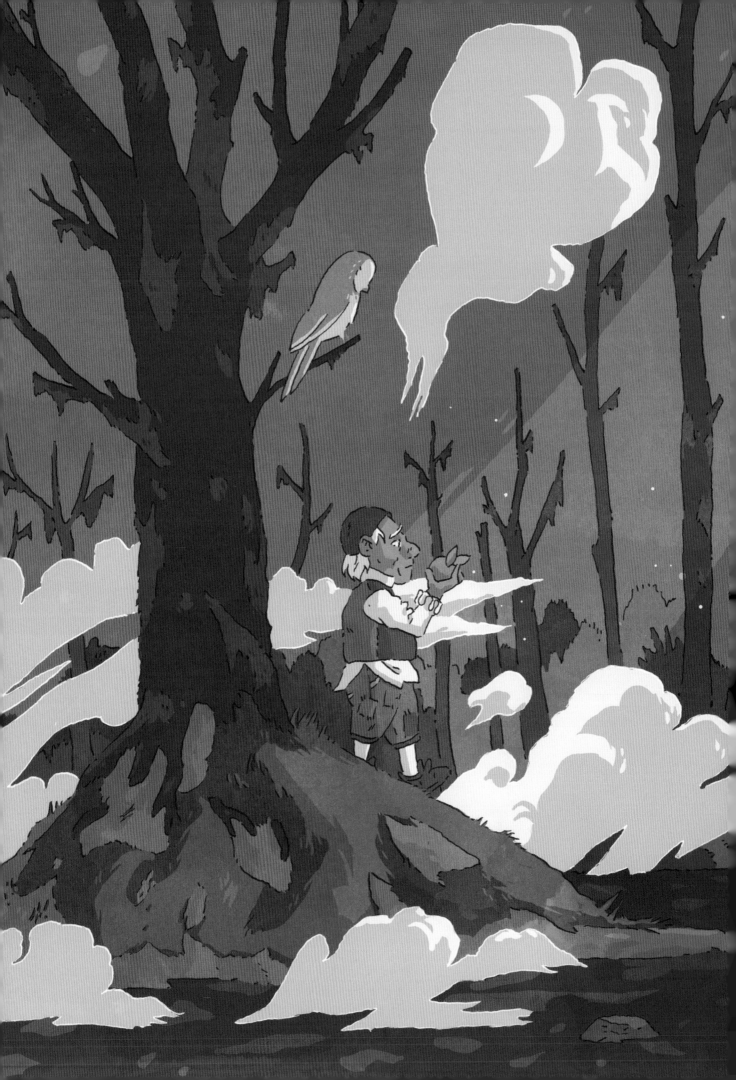

Rewatching *Labyrinth* reminded me of just how visually striking every single scene of the movie truly is. There's never a dull moment for your eyes to wander off the screen.

Jim Towe

I wrote to Jim Henson when I was ten years old and was shocked to receive a signed letter back from him. I was constantly drawing all the creatures from his different properties and always marveled at the level of background details in all of his worlds. One of the things that Jim wrote in his letter was that he hoped I'd keep drawing.

{ *. . . [Henson] hoped I'd keep drawing.* }

Those words of encouragement have always stuck with me and pushed me to move further.

Robb Mommaerts

Facing page: *Art by Kyla Vanderklugt.* Following pages: *Art by Faith Erin Hicks* (left) and *art by Kelsey Beckett* (right). Pages 66–67: *Art by Jim Towe.*

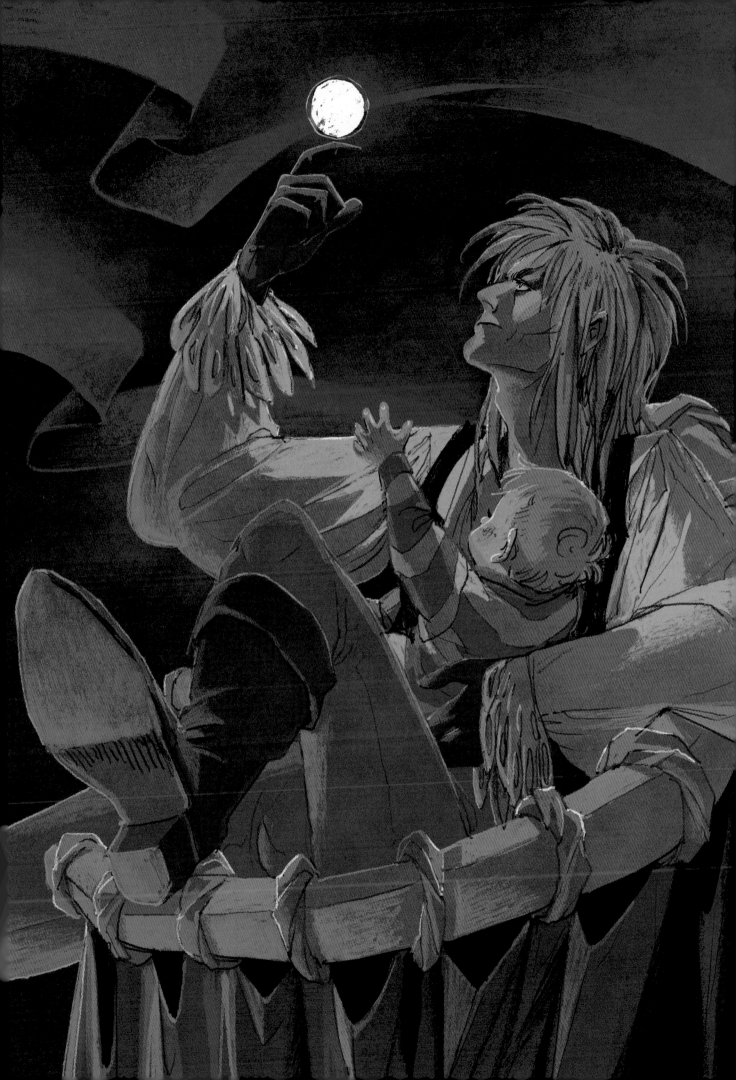

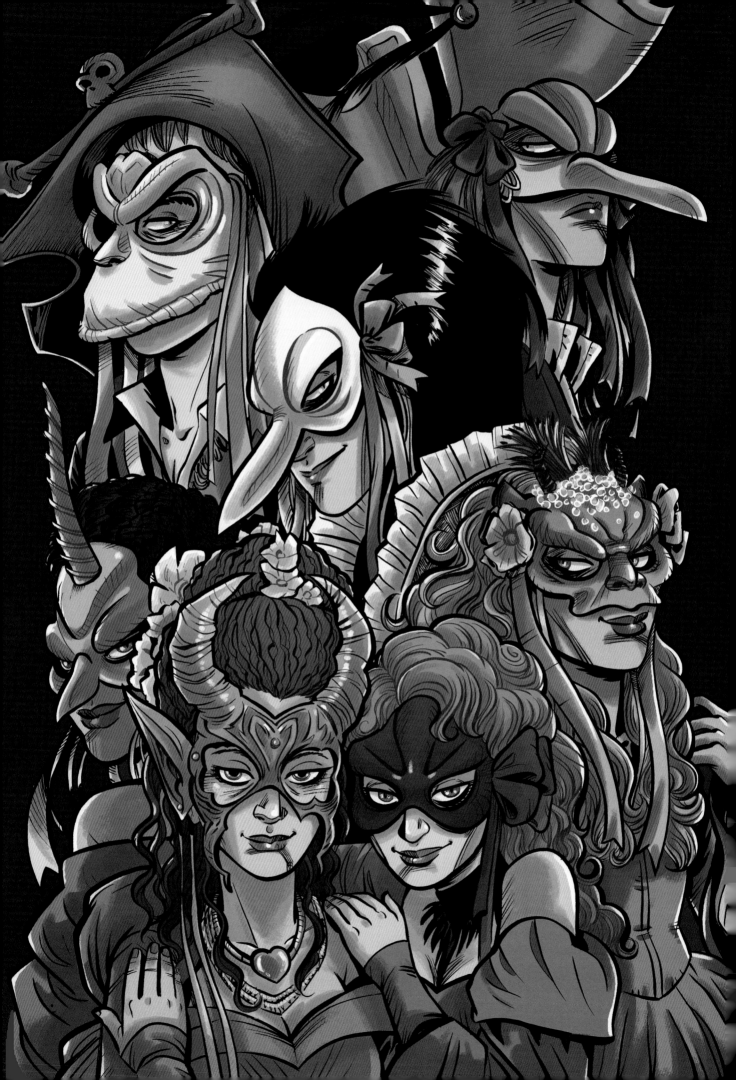

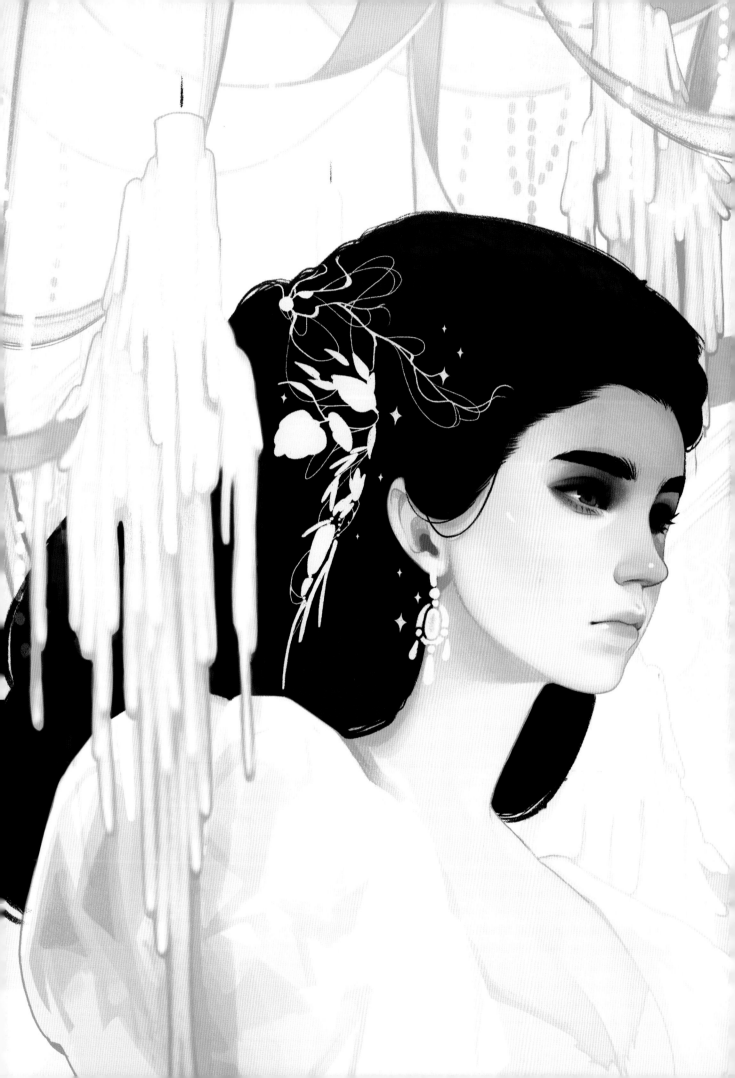

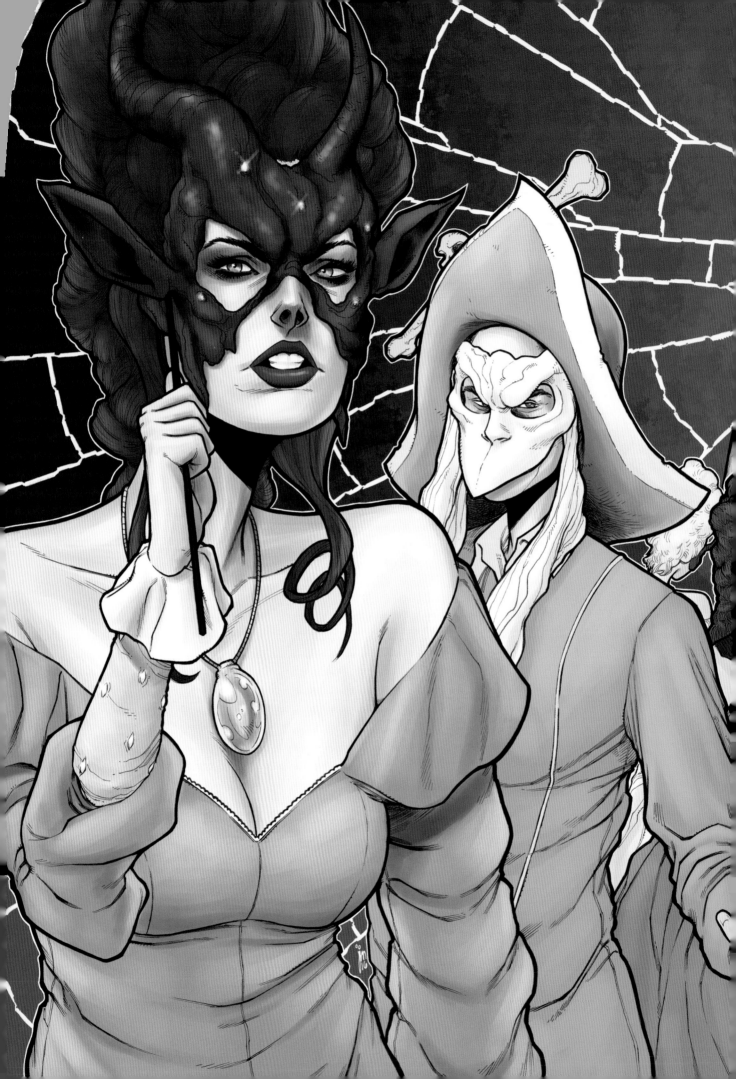

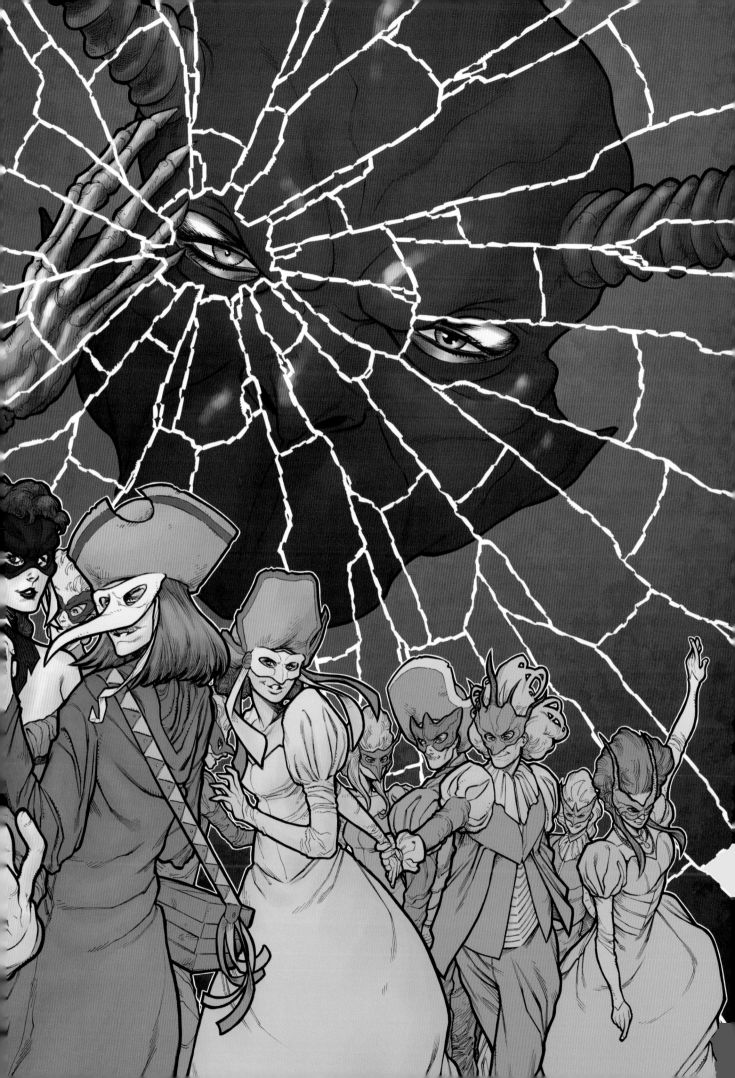

I was sixteen when I first saw *Labyrinth*; a bit older than the target audience, but probably the ideal age to appreciate the nuance of Jareth and Sarah's love/hate waltz. And certainly the perfect age to be captivated by Bowie as more than just a shadowy bad guy. Like so many others, *Labyrinth* was the catalyst for an obsession with Bowie, and I immediately began to inhale everything he'd ever recorded, written, done, or said, amidst daily multiple watchings of my brand new *Labyrinth* DVD. I joined what was, at the time, the largest Bowie fan community online. It was for "serious" fans. People decades older than me that had actually seen Ziggy & the Thin White Duke IN THE FLESH. I wanted to be a "serious" fan, too. And it quickly became apparent that that meant keeping my love of *Labyrinth* under wraps. The mods and old-timers made no secret of their dislike of the movie, grounded in some idea that Bowie himself was ashamed of it, that it was kid's stuff, a misstep in an otherwise flawless career. If you revealed that you were introduced to Bowie's work through *Labyrinth*, you were labeled a poser and possibly banned. I lied by omission and tried to blend in. If I found myself in a conversation with someone who tipped their hand, then I might let my Freak Flag fly, but otherwise, I contented myself with lurking around the small *Labyrinth* fanfic/fanart communities.

culture, but it was really a beautiful and heartwarming thing to see people loving what they love and sharing it with others with such abandon.

This is a little embarrassing to admit, but Mr. Bowie often made appearances in my dreams, in which we were old friends, talking about normal everyday things. For someone who mostly has excruciating nightmares, they were particularly precious. When he passed, it had been a while since he'd showed up in one. I know I'm not alone in having had difficulty accepting it at first. It's a cliché, but true, that he really was one of those legendary types who seemed to exist above things as mundane as illness and death. I hadn't shed more than a few tears (and I cry at the drop of a hat) because it honestly didn't seem real. Then about two weeks later, I dreamt I was teaching a group of small children in some sort of art workshop. Suddenly, there was Bowie. He had brought a hoard of Labyrinth designs, photos, props, and costume pieces, and sat and talked with us for hours about them, beaming. Finally, a handler approached, telling him it was time to leave. He gave us all a warm goodbye, and rode away. Even in my dream world, I knew it was the last time I would see him. I woke up sobbing, and the tears haven't stopped much since then.

{ *... Labyrinth* has a power that's hard to explain, and hard to shake. Don't try to. }

Eventually, I started working professionally and became too busy to contribute much to either. As the "World Falls Down" occasionally popped up on my Bowie Favorites playlist, *Labyrinth* grew less and less a part of my life (although I did whip up a last minute Jareth costume for a Halloween screening a few years ago, because ya gotta).

Over a decade after I first saw Jareth and Sarah on screen, I finally joined tumblr (years behind the cool kids). I searched *Labyrinth*, expecting a few results, probably from fans around when the movie debuted and my later generation—ancient in internet years! But I was floored by how many people still LOVED this movie, and how many were loving it for the first time every year, every day. Unabashedly. Without judgement. And they loved Bowie and everything he's gifted us with, because really, how can you see this movie and not at least be totally fascinated by him? Say what you will about tumblr and internet fan

It's one of my most painful and beautiful memories of him, and it didn't even actually happen. But something in the universe knew I needed it. I needed to be reminded what Bowie meant to me, to so many others. That he would have wanted us to believe—in fairy tales, in magic, in the beauty of the light and dark inside of us. To love what we love fervently, and above all, to not give a damn what anyone else thinks of us.

Like Jareth, *Labyrinth* has a power that's hard to explain, and hard to shake. Don't try to. Live in that world while you can, share it with new visitors, let it inspire you as it has so many others. To some, it'll always be just a kid's movie, and a strange one at that. To us, it'll always be pure magic.

Rebekah Isaacs

Facing page: *Art by Rebekah Isaacs with colors by Dan Jackson*. Following pages: *Art by Daniel Bayliss*.
Page 72: *Art by Justin Hilden*. Page 73: *Art by Douglas Holgate*.

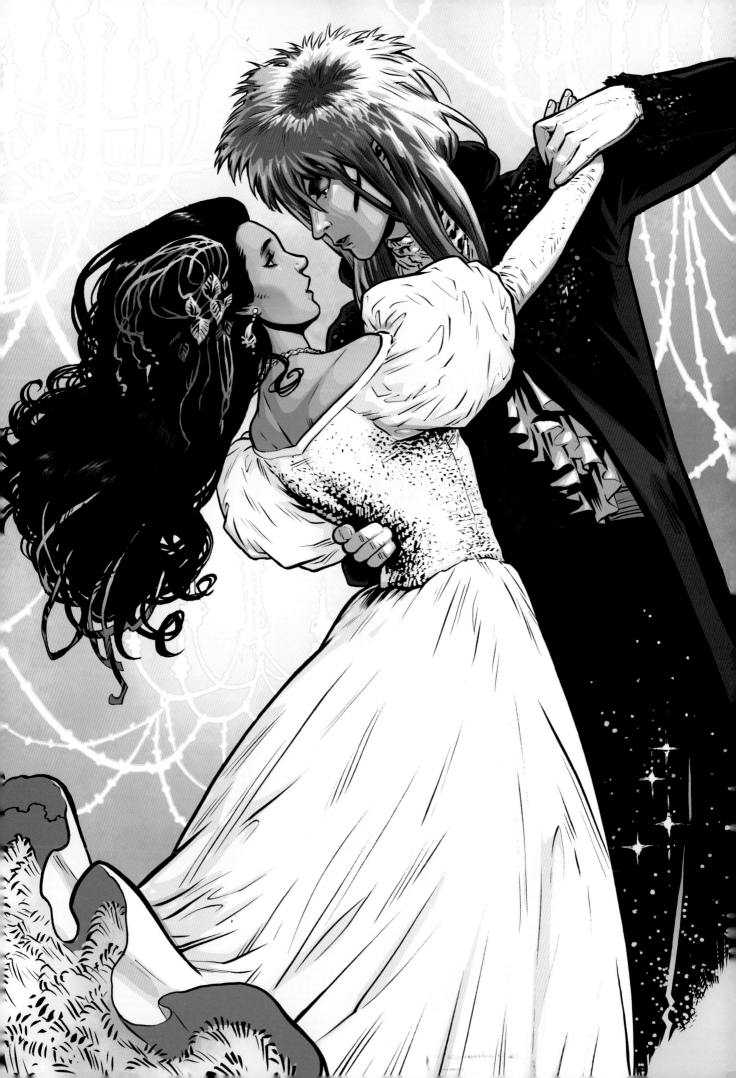

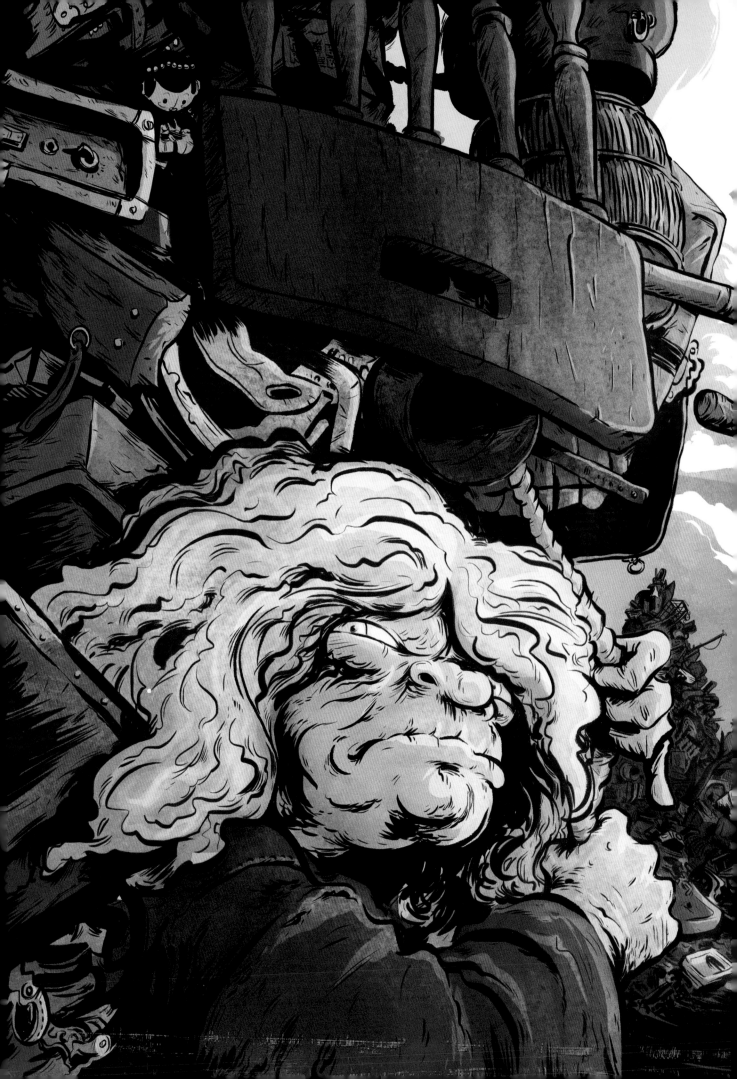

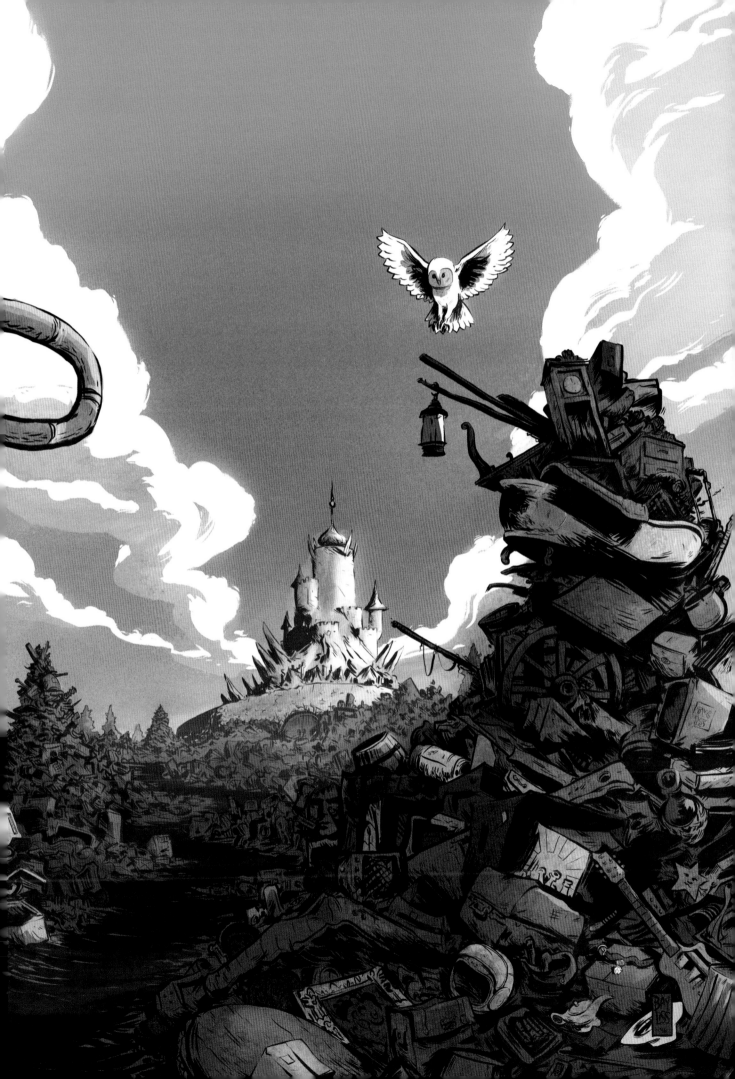

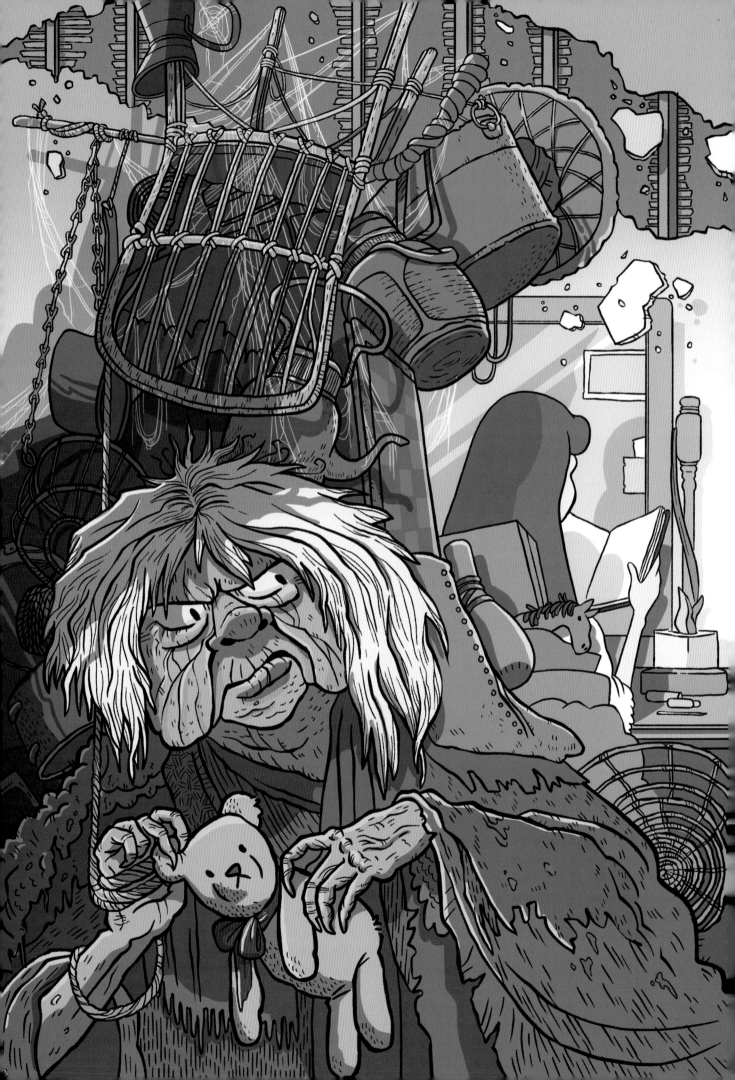

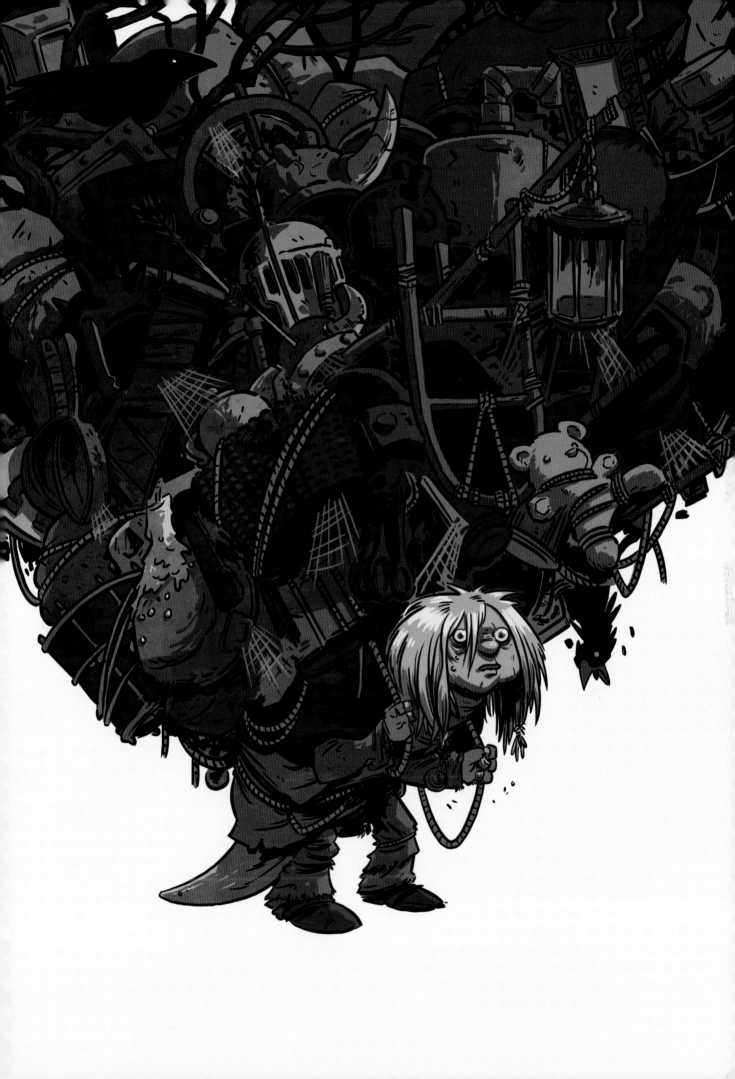

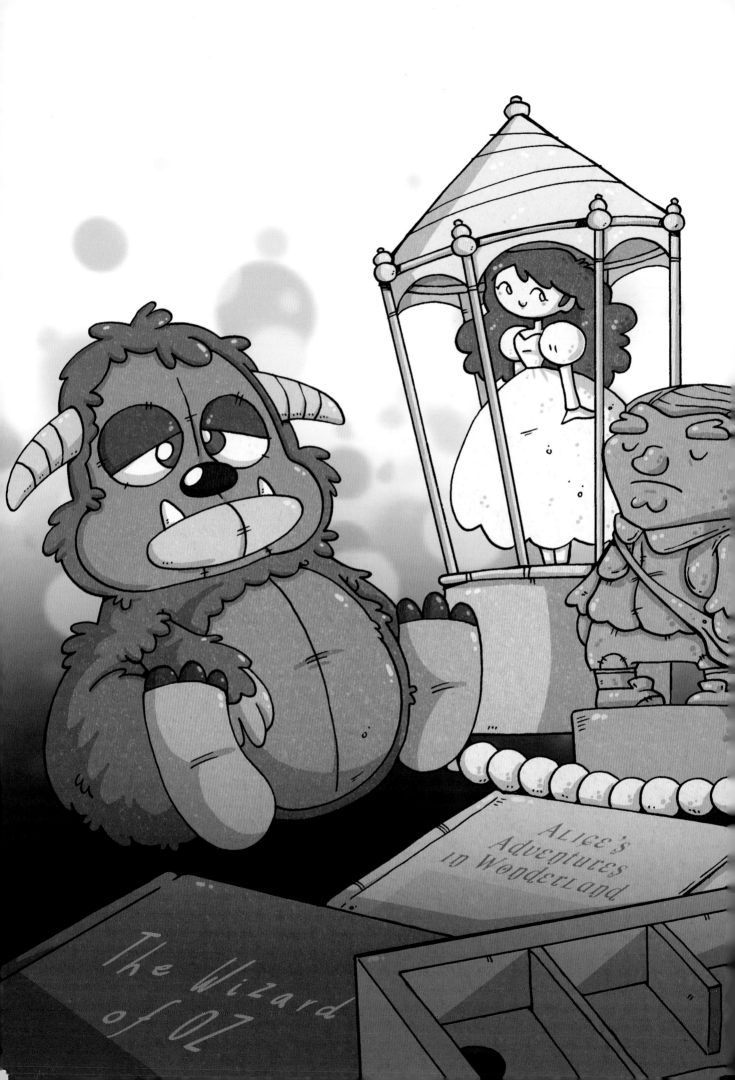

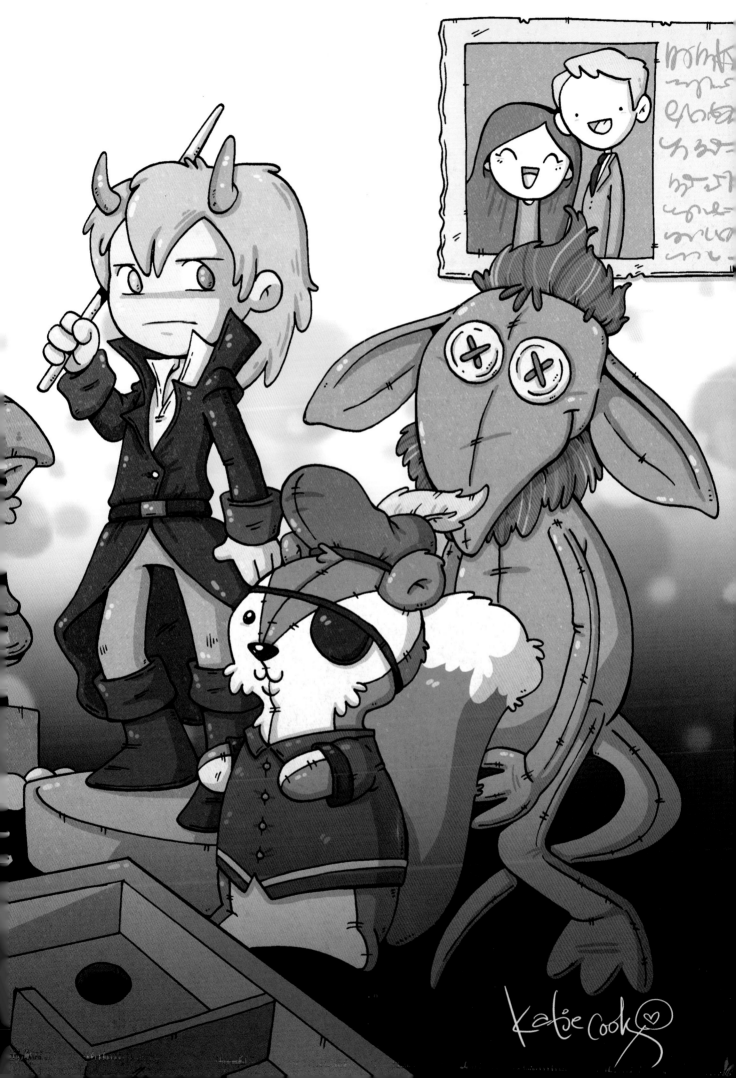

Labyrinth was one of my favorite movies as a kid. It was a fantasy world that was lush and beautiful and dark and mysterious and so very, very real to me. I think we wore out the VHS at one point . . . I still have the faded poster for the movie that I had as a kid hanging in my home.

{ **. . . a fantasy world that was lush and beautiful . . .** }

I'm at a point now where I watch it with my daughters and I can see the beauty of the movie and the story captivating them as much as it did me.

Katie Cook

Previous pages: *Art by Katie Cook*. Facing page: *Art by Tyler Jenkins.*
Following pages: *Art by Mike Huddleston* (left) *and art by Robb Mommaerts* (right).

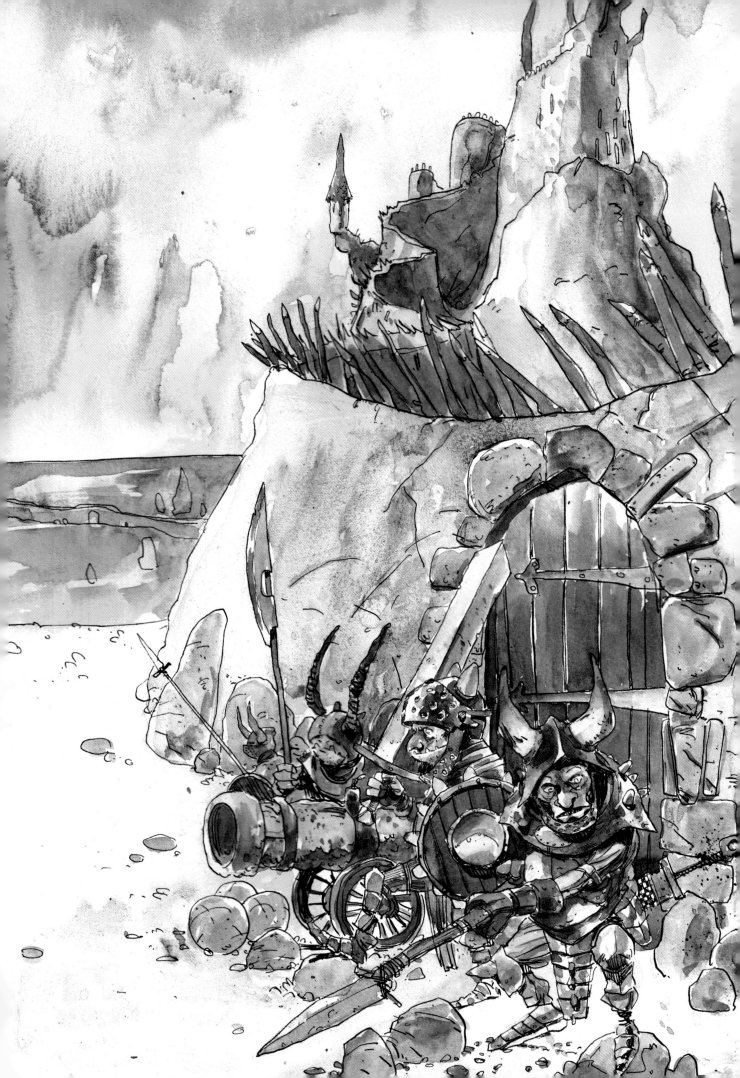

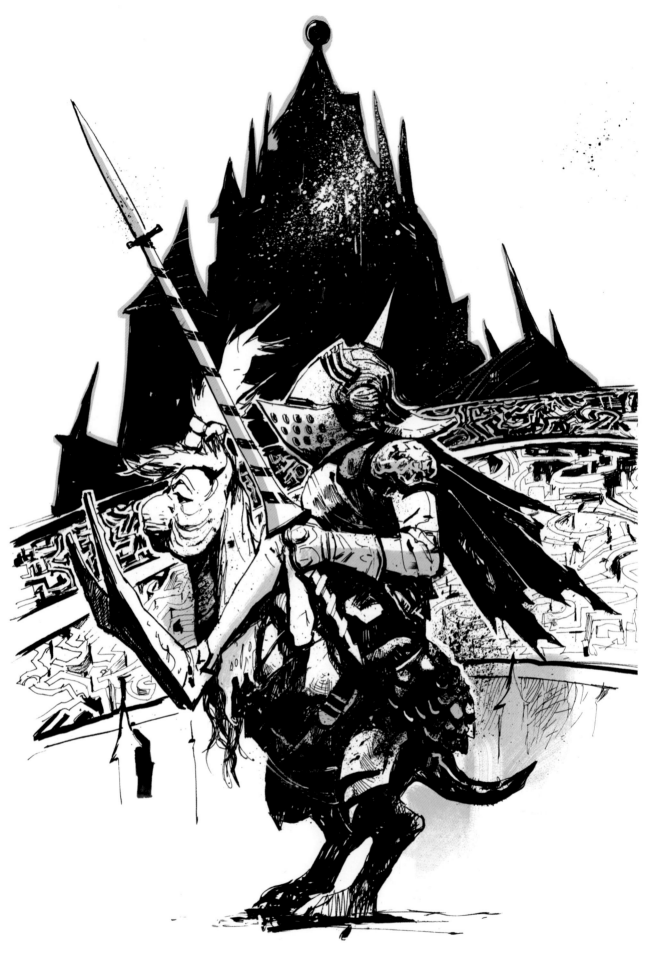

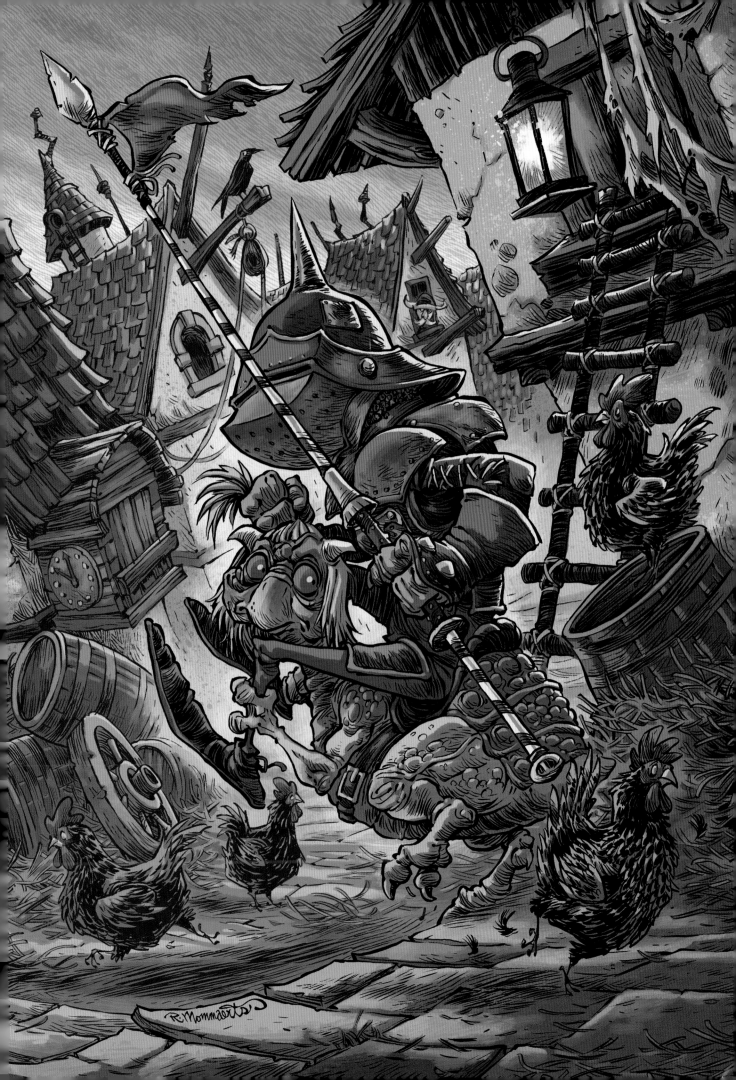

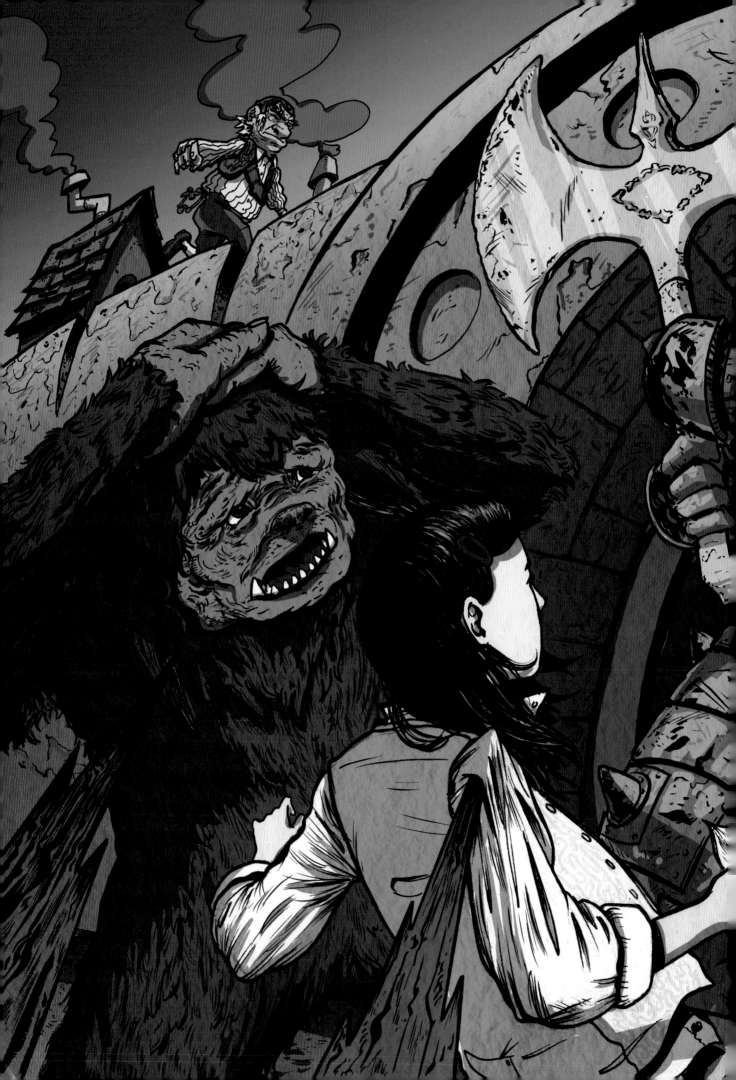

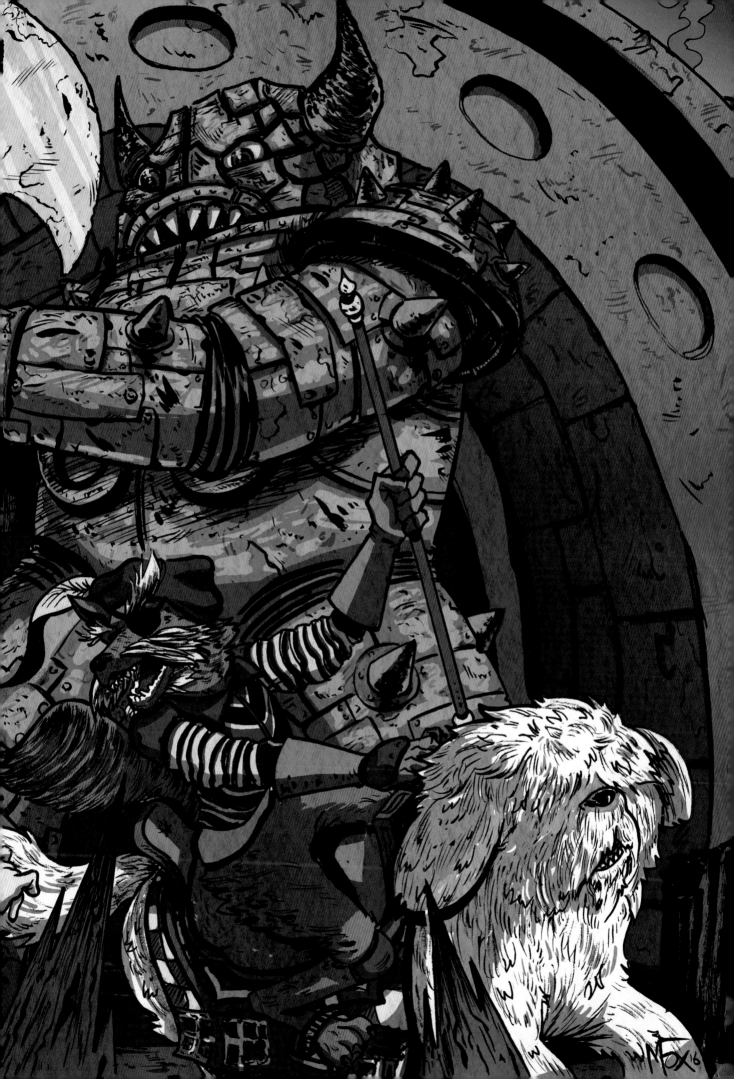

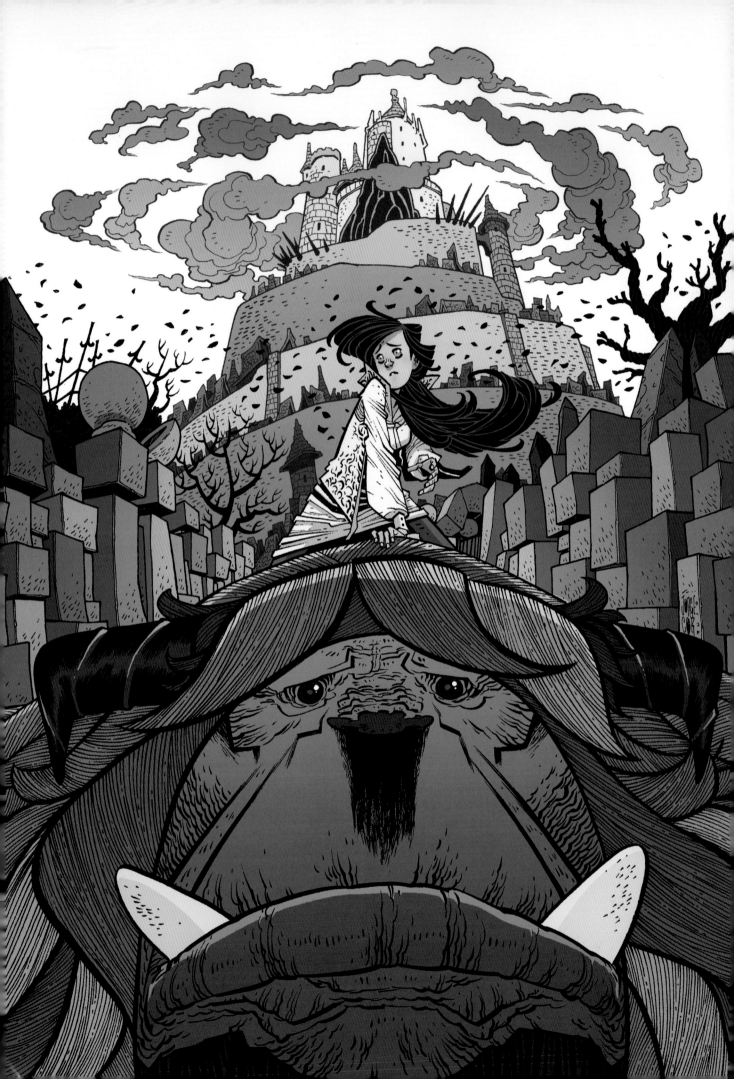

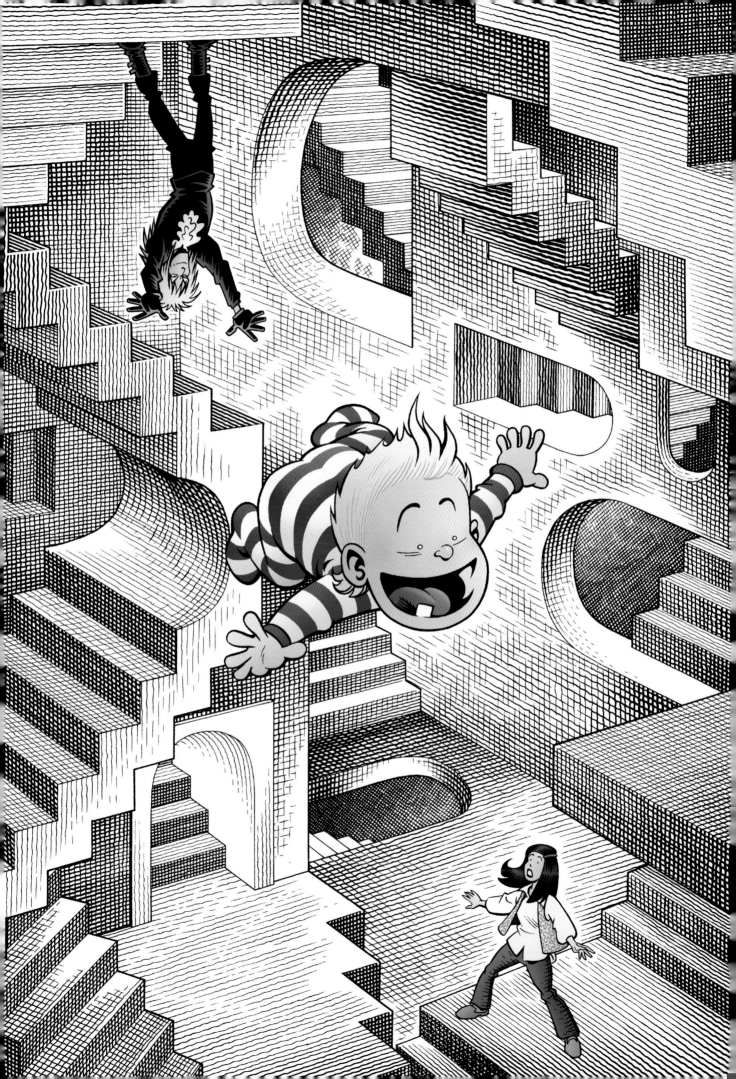

I'm very confident that I am among the world's biggest David Bowie fans. It could even be qualified as a dangerous obsession.

As a kid, I first discovered Bowie on the June, 1974 issue of *Creem* magazine. I was making my usual dig through a drugstore comic book rack when I saw the cover of a rock 'n' roll magazine with Bowie and his then-wife, Angie, in bright colored superhero space costumes looking like they had just arrived from another planet. To say that cover photo intrigued me would be an understatement.

At that time, I could probably limit my top five favorite musical acts to three: The Beatles, The Monkees, and The Partridge Family. The Beatles because they seeped into every aspect of my limited knowledge of pop culture, and The Monkees and The Partridge Family, because I saw them regularly on TV. I'd yet to have my own radio or stereo. But that *Creem* magazine Bowie cover changed all that. I bought it and started reading it on the walk home, making a detour to Rickets Music Store where I bought the just released 45 single of "Rebel Rebel" with "Lady Grinning

The Kinks, etc. I picked up every Bowie album up through *Diamond Dogs*, and connected all the "Glam Rock" dots with Mott The Hoople, T. Rex, Roxy Music, and moving on to Led Zeppelin and Pink Floyd, and on and on. This remains one of those inspired and inspiring periods of my life. A crash course of discovery that is only equalled by a similar crash course when I found my first comic shop and found I could fill in all the holes in my comic book collection and access, and drink in, the history, and "Who's Who" of the art form.

And so, somehow, this all this eventually leads to *Labyrinth*. My older cousin, Laurie, had taken me to my first R-rated movie, *The Man Who Fell To Earth* (a brain-frying experience, to say the least, but that's another story), where David Bowie actually plays an alien trapped on earth, desperately trying to send aid back to his dying planet. His most perfect role. And while Bowie always intrigued on screen, he only really came close to matching the perfection of his alien role twice, as a vampire in *The Hunger* (a much too brief but haunting part), and of course, as The Goblin King in *Labyrinth*.

{ *Labyrinth* is the perfect place for parents to introduce their children to David Bowie through the magic of Jim Henson. }

Soul" on the flipside. I took it home and my life changed in countless wonderful ways. I would play each side over and over again and knew I had to have more. This started an exploration of all things rock 'n' roll.

All my paper route money then went to buying record albums and more magazines telling me who was who and describing sounds which I just had to hear for myself. Dad gave me his old stereo and my life then largely consisted of reading comics in my room while playing every album in my rapidly growing collection, and eating up every bit of information on the album covers.

I filled out my Beatles collection, and curated the "British Invasion" with The Rolling Stones, The Who, The Zombies,

But what was especially cool about *Labyrinth*, was it actually had David Bowie music in the film!!! GENIUS!!! Of course, we get introduced to the always lovely and talented Jennifer Connelly, and we get pulled into the most childlike adventureland since *The Wizard of Oz*.

For a Bowie fanatic, *Labyrinth* is the perfect place for parents to introduce their children to David Bowie (*The Man Who Fell To Earth* is for much, much later) through the magic of Jim Henson. A gateway drug for both. A timeless classic that gets more classic as time goes on.

Michael Allred

Pages 80–81: *Art by Matthew Fox*. Previous pages: *Art by Jorge Corona* (left) *and art by Roger Langridge* (right).
Facing page: *Art by Michael Allred with colors by Laura Allred*.

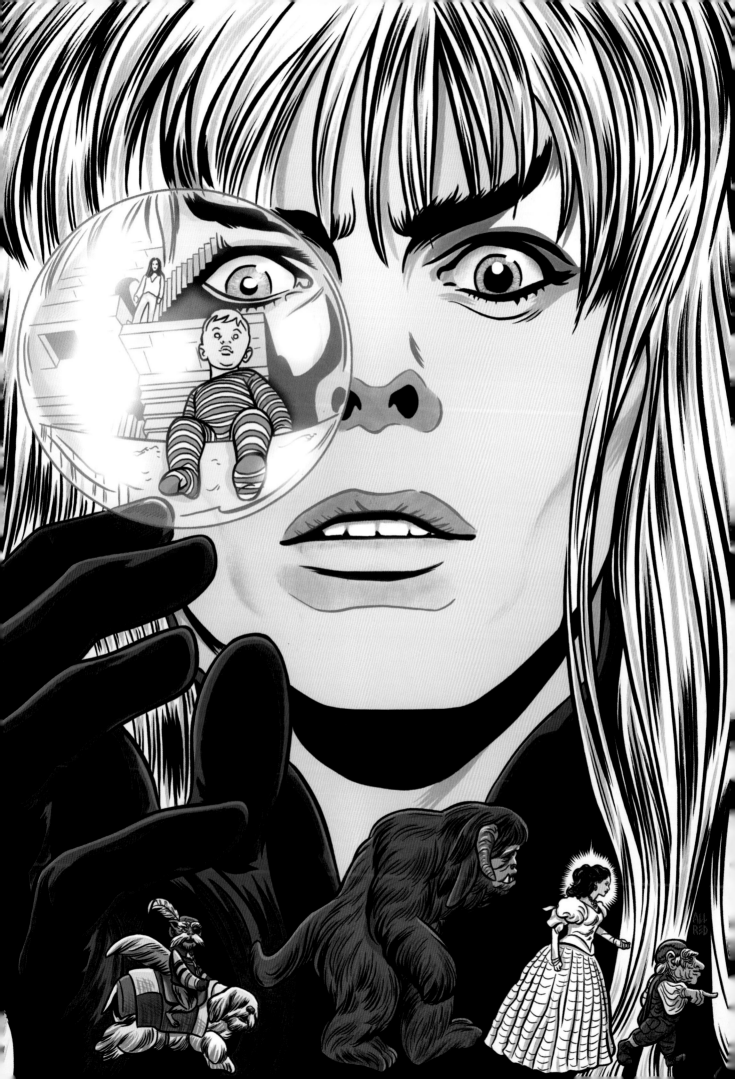

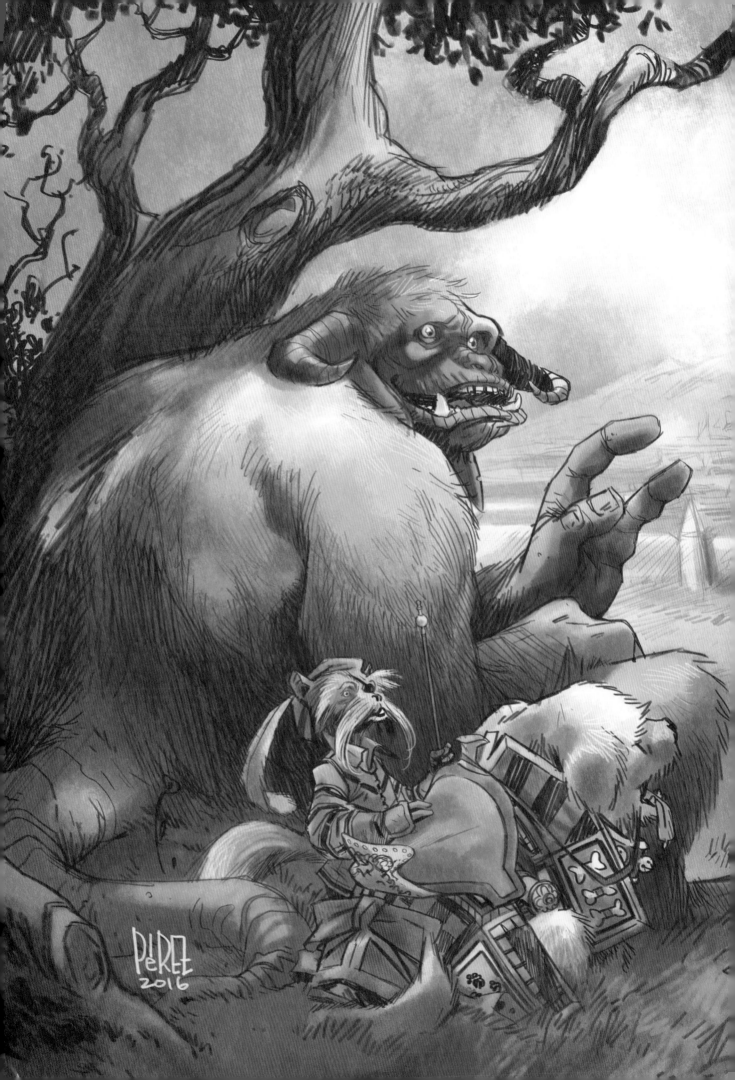

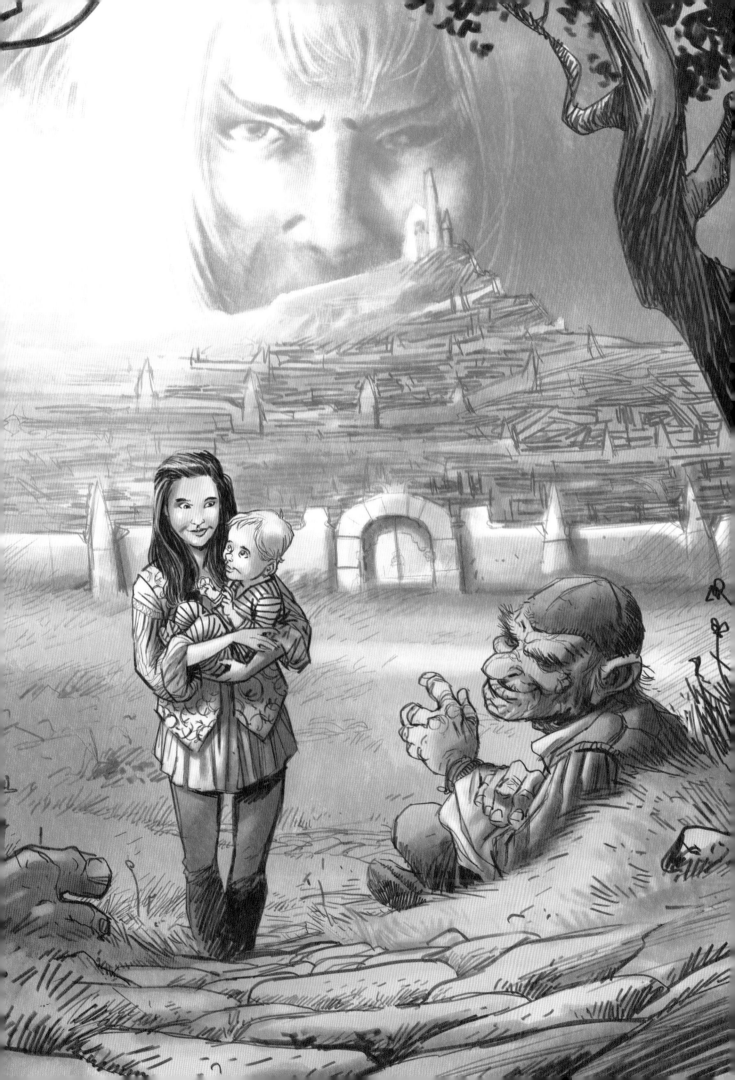

There are elements in one's childhood that will mold the psyche growing up. Catalysts for the imagination. I can boil mine down to *Star Wars*, *Indiana Jones*, *The Blues Brothers*, and *The Muppets*, the last of which, along with *Sesame Street*, especially branded my sense of humor. Oscar's grumpiness, the shyness of Mr. Snuffleupagus, the zaniness of Gonzo,

{ **My path as a storyteller began with Henson . . .** }

the soft-hearted nature of the monstrous Sweetums, and Fozzie's comedic repertoire and the fact that he never gave up, no matter how many detractors moaned and groaned from the audience. I never had the chance to see *Labyrinth* in the theatre; my first glimpse at the creatures that peppered the world of the Goblin King were revealed to me in a cereal box prize. From that point on, Ludo adorned one of my earlier sketchbooks, till years later when I finally enjoyed the movie. My path as a storyteller began with Henson, and recently life has brought me full circle and given me the opportunity to become part of his legacy, and I can only hope to inspire as much as he so did for me.

Ramón K. Pérez

Previous pages: *Art by Ramón K Pérez*. Facing page: *Art by Jeff Stokely*.

88

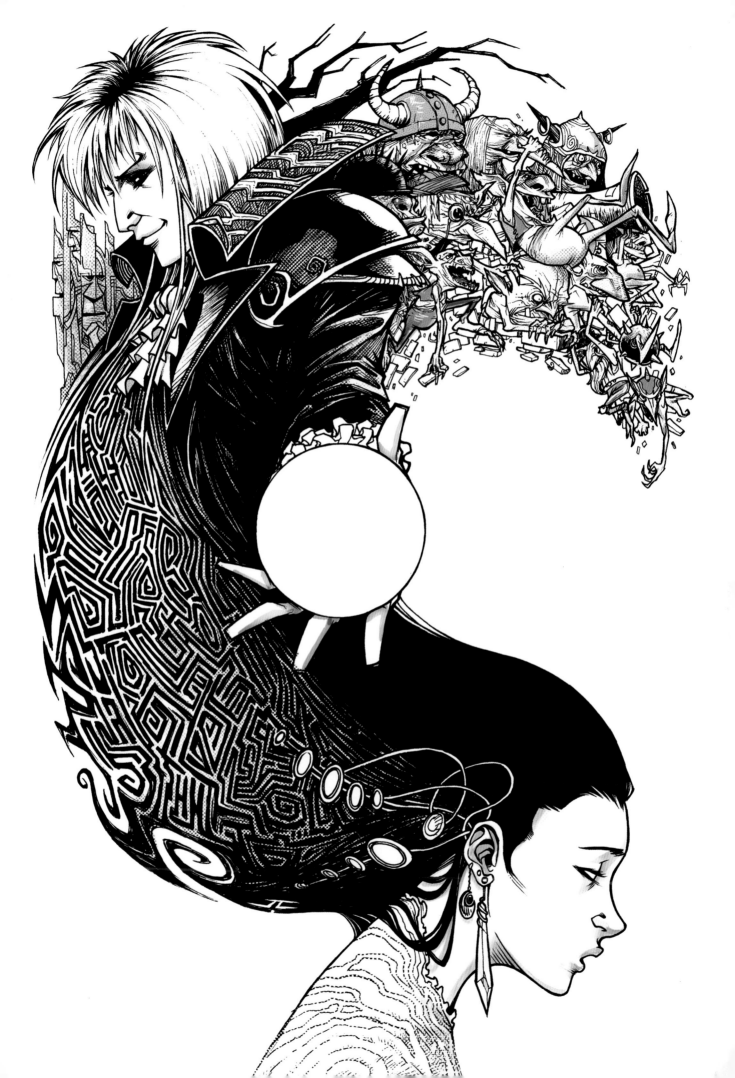

At the influential age of ten or so, my dad rented *Labyrinth* for me. It was my first time seeing it and about halfway through, I knew he wouldn't have rented the movie had he seen it beforehand. The pure outlandishness of the world, the absurdity and honesty of the characters, the way one girl questioned her surroundings and the choices of

{ **. . . it's no stretch to say it's one of the most influential films for me.** }

those in charge, it's no stretch to say it's one of the most influential films for me. Because of that, I'm indebted to my dad and Jim Henson for instilling me with a healthy dose of skepticism, a lifelong love of goblins, and a life-transcendent love of David Bowie.

Jeff Stokely

Facing page: *Art by Dylan Burnett*. Following page: *Art by Steve Morris*.

90

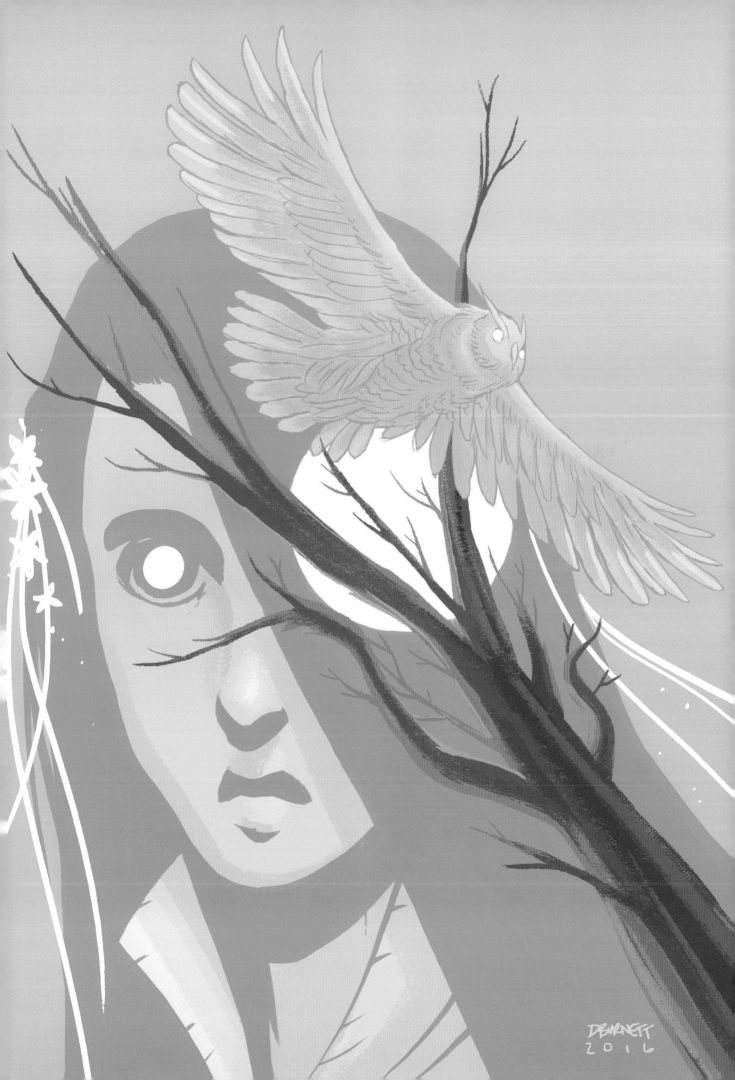

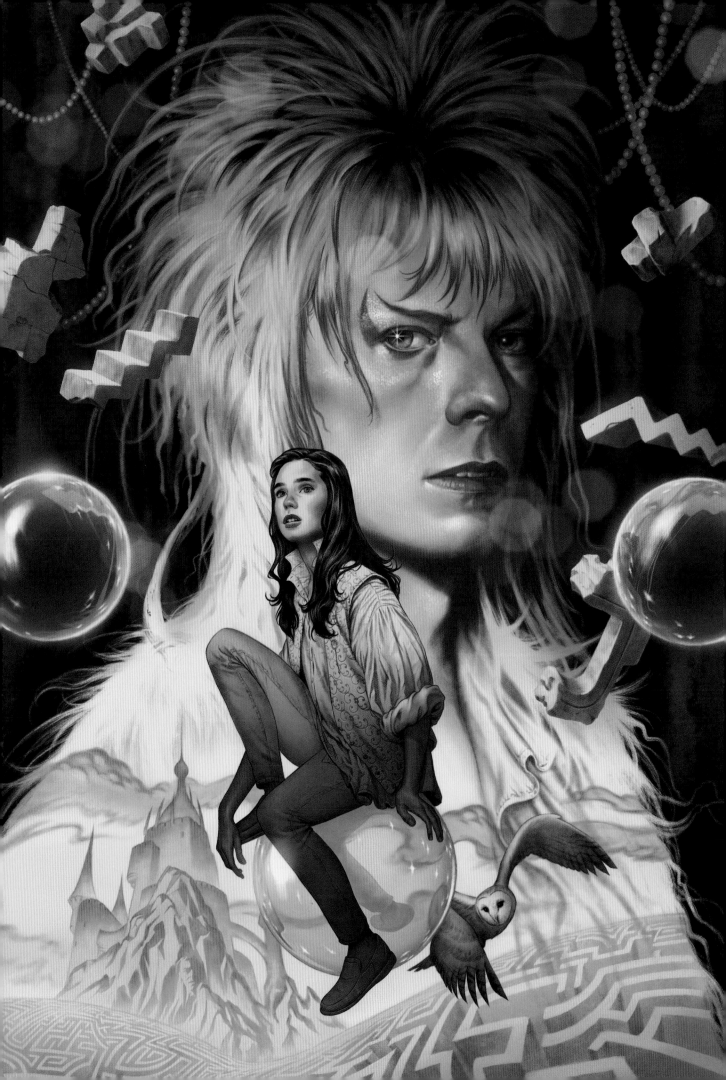

"I don't know why,
but every now and then in my life,
for no reason at all, I need you.
I need all of you."

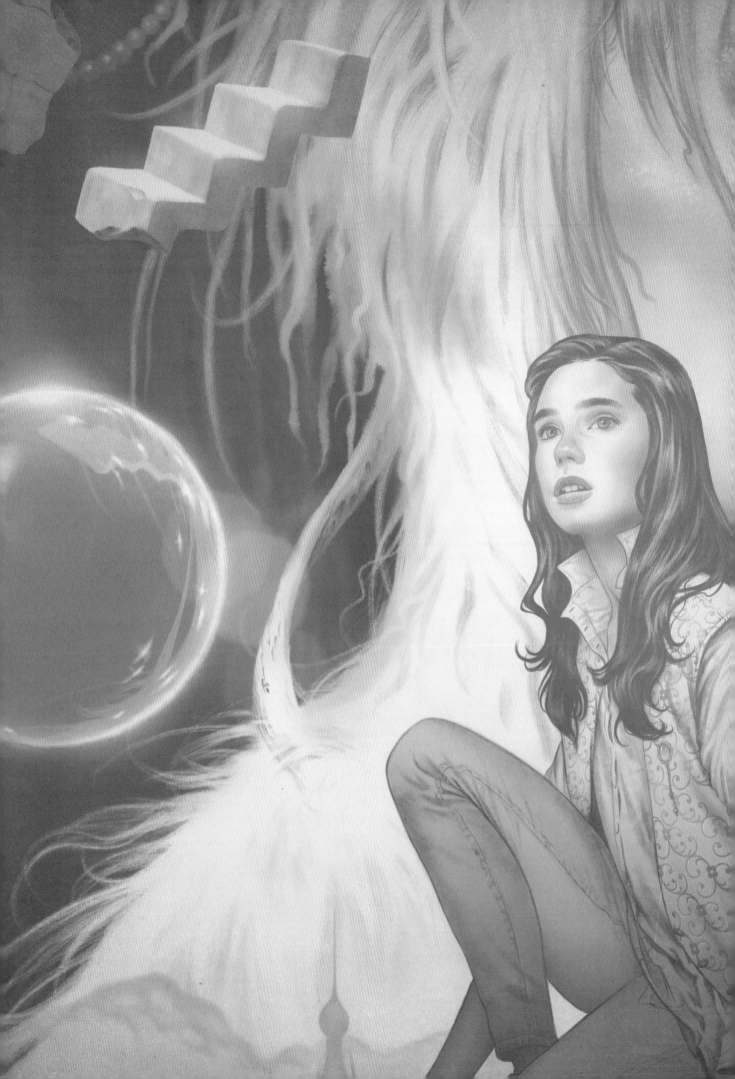

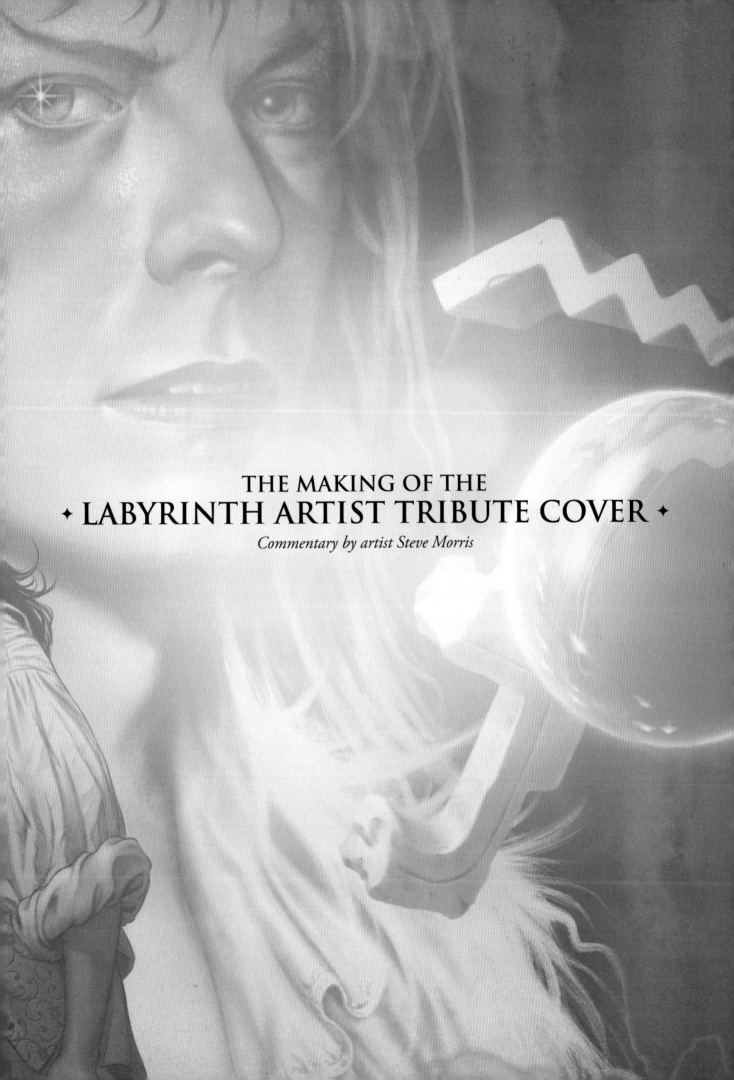

THE MAKING OF THE
✦ LABYRINTH ARTIST TRIBUTE COVER ✦
Commentary by artist Steve Morris

It was an exciting privilege to create the 30th Anniversary *Labyrinth Artist Tribute* cover, which itself felt like a tribute to David Bowie, with his passing so soon before I received the assignment. I was given an open playing field for exploring ideas, but before brainstorming in earnest, I re-watched the movie to take a walk once again in its titular maze. I pored over the movie, reacquainting myself with the characters: youthfully spirited Sarah, seductive trickster Jareth, and the enigmatic labyrinth that's both conduit and obstacle between the two characters.

Fresh from my cinematic excursion to the Goblin King's domain, my mind crackling with imagery, I put stylus to drawing pad. My normal digital sketch style is a barely tethered collection of squiggles, which works for an editorial that is accustomed to interpreting my digital spaghetti. But seeing as how I was new to BOOM!, I felt it was important to offer elaborate initial renderings to help sell my ideas. I wasn't concerned about the likeness at this stage, but I did spend a little time to get them in the far outfield of the general ballpark. One thing that *Labyrinth* fans may notice is that I didn't use the more traditional Jareth attire in any of my sketches. I chose his all-white finale costuming because it would stand out better on a dark background . . . I also loved the diaphanous quality of the hair cape he wears, which mimics his own hair.

I explored several options, always with the intent of maintaining a mix of wonder, apprehension, and the sinister, within the composition. While the focus of all my sketches was planted squarely on Sarah and Jareth, I experimented with different ways of incorporating the labyrinth as edifice and/or design element. In some sketches, the labyrinth was purely a design element (Fig. 1), while in others it became an extension or proxy of Jareth himself, forming a prison for Sarah (Fig. 6, Fig. 7). In the sketch which became the final art (Fig. 12) we are able to see the omnipresent scope of the maze, its vast and scrawling walls which seem to comprise all of Jareth's kingdom.

After having drawn several "base" ideas, I started to mix and match elements from them to form additional possibilities. Some of these sketches are shown here and on the following pages.

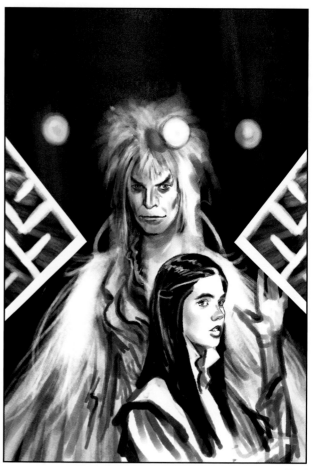

Fig. 1

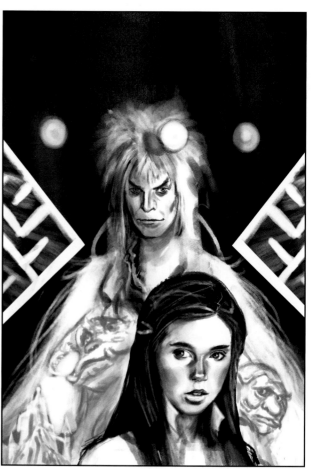

Fig. 4

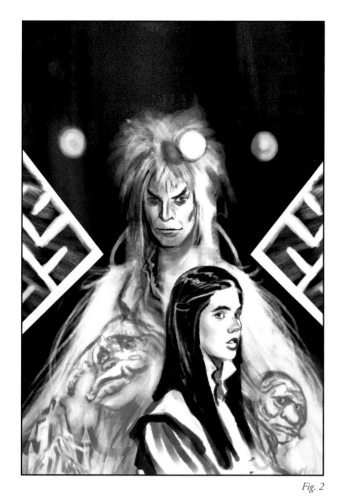

Fig. 2

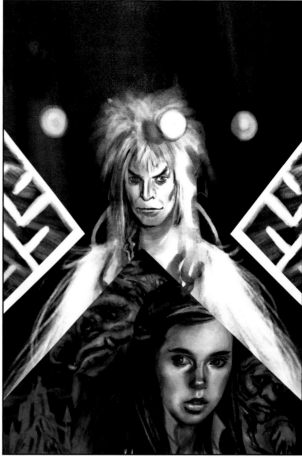

Fig. 3

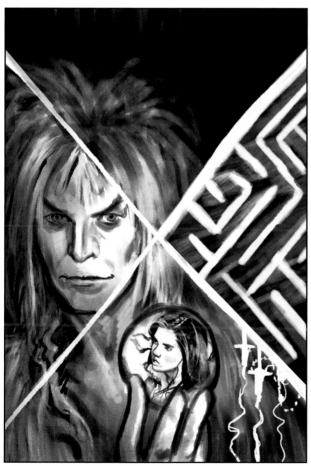

Fig. 5

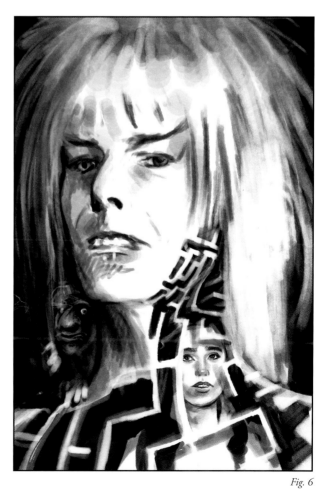

Fig. 6

Having made over fifteen sketches, I sent them to editor Sierra Hahn for perusal. I had my favorites, some for composition and others for content. I waited eagerly to to find out which they might pick, but with such a large scope of material to work from I couldn't be sure I hit the sweet spot that editorial might have had in mind. Luckily, one of my sketches proved to hit the mark and I was given permission to move forward on the drawing stage. The sketch they chose was one of my favorites because it had an especially large version of Jareth and I liked the falling/floating chunks of wall, which were a representation of the crumbling labyrinth towards the end of the movie.

Before crossing from sketch to drawing, I have an intermediate stage for reference collecting, which I could also call my procrastination stage. I started collecting reference material for the likenesses of both David Bowie and Jennifer Connelly, downloading images from the internet as well as taking screen grabs from the movie. I also started hunting for photos of the costumes they wore, Sarah's brooch, Jareth's castle, etc. You never know what you will or won't find: while I couldn't manage to locate good images of Jareth's finale costume, I did find a photo of the prop loafers Sarah wore. In the end, and I assume because of the age of the movie, I wasn't able to locate many prop images, so I spent extra time with the movie, searching for the sharpest moments to capture the pattern on Sarah's vest, her brooch, and several other bits.

Once I had thoroughly scoured the internet and movie for every last bit of reference, I was ready to move onto the drawing. Just like the sketch, the drawing is created digitally in Photoshop, utilizing several layers so that the individual components can be shifted and scaled at ease. I start by using preexisting layers and art from the sketch file, cleaning them up, erasing and refining the lines. This is a pretty straightforward process of shading, drawing, texturing, and pulling together the likenesses from multiple references.

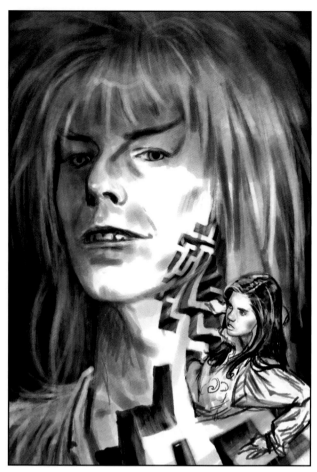

Fig. 7

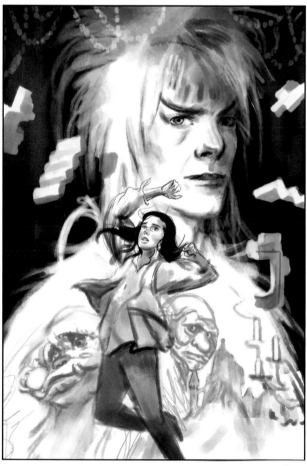

Fig. 9

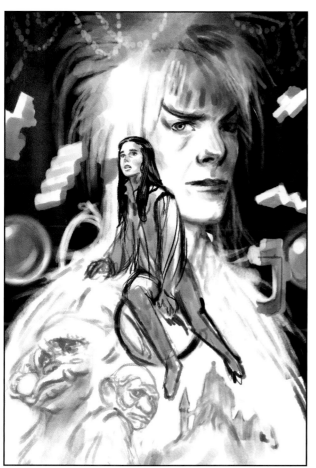

Fig. 8

Fig. 10

EDITOR'S NOTE

I've had the pleasure of working with illustrator Steve Morris for many years. We first met when he began drawing covers for Angel & Faith *and* Buffy the Vampire Slayer *during my tenure at Dark Horse Comics. His cover work is among some of the best out there—dynamic, thoughtful, original, and packed with symbolism. All of the details an editor aspires to bring to every book. I knew Steve would nail the likeness of not only David Bowie and Jennifer Connelly, but Jareth and Sarah. He'd bring out the light, the fantasy, magic, and wonder so inherent in any Jim Henson character. I also knew we'd get a wealth of cover options to examine—all equally as inspiring as the next. Figure 7 was actually my favorite sketch, but I also recognized that it was a little scary, a little grotesque. Yet I felt that it was a completely original approach. Figures 2 and 10 were the next to stand out, and the editorial team at BOOM! gathered around to weigh options and discuss alternatives. We asked Steve to revisit Figures 4 and 10. Our comments:*

Figure 10: Please lower everyone, perhaps making Jareth a little smaller or cropping off more of his body at the bottom. We love Sarah on the crystal ball, but worry she's just a tad too big or covering his face too much. Maybe nudging her a bit more to the left will help so that she's less centered and the crystal balls could then be a little off point. Having Ludo and Hoggle on the bottom feels like too much additional information with this particular composition, so perhaps look at incorporating the maze here, bringing in more design that could drop back than world building.

Figure 3: In this drawing we'd like to lose the triangle shape the characters are in and incorporate them (or collage them) into Jareth's shape (like you suggest with Ludo and Hoggle in Figure 10). More Drew Struzan-homage than not. That headshot of Sarah is stunning and we really love the composition of her flanked by Ludo, the castle, and Hoggle, with the architect (Jareth) rising above them. But the three triangle shapes feel a little oppressive, and hard, so we thought losing the triangle at the bottom, with the characters in it, might address our concern.

Steve came back with several more options to choose from. (An editor's dream!) and we settled on Figure 12. Having Sarah's knee bent up felt more natural as well as dynamic. Once Steve started work on the final art he started to build in more world building elements, including an "Easter egg" for the discerning eye.

Jareth's glass spheres were a point of debate for me, as to whether they should be hollow or solid because of the way each refracts light. I eventually chose to make them hollow because solid glass spheres refract by flipping (what's behind them) vertically and horizontally, which made the spheres feel overly complicated and pulled attention away from the characters.

Towards the end of finalizing the drawing I felt that it needed a little something, so I added the owl (Jareth's transformed-self), which filled a vacant space and added more motion to the piece.

I submitted the drawing for approval, and with a minor tweak to Jareth's expression, I was on to the coloring. Like the sketch and drawing, I color the art in Photoshop, compressing some of the line and shading layers, but leaving shapes separate so I can still move them. With the relative complexity of the image and all its various elements, I used a limited pallet of colors and relied on tone and contrast to separate the shapes and create a sense of atmospheric perspective. I picked warm yellows and oranges since they were a fixture in the movie, but I punched them up to heighten the fantasy aspect. Lastly, I added fuzzy dust orbs and orange color holds on Jareth's face as the finishing diffused gauze to complete the dreamy atmosphere of the final piece.

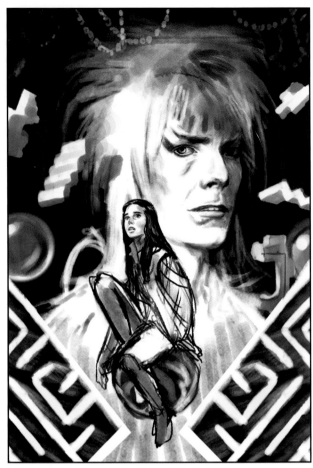

Fig. 11

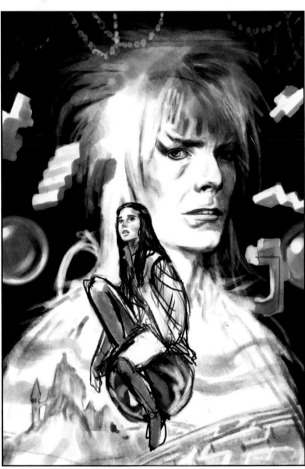

Fig. 12

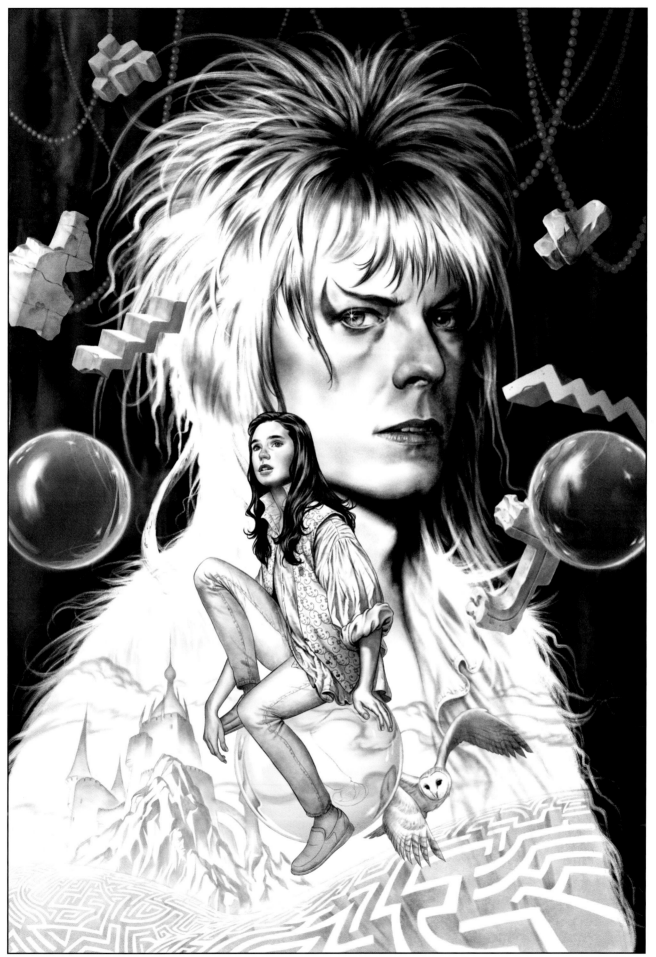

Fig. 13

• ABOUT THE ARTISTS •

Laura Allred has been "artistically inclined" her entire life, but that inclination was accelerated when she met her husband, Michael Allred, and he turned her on to the wonderful and thrilling comic book art form, and she launched into a career of coloring comics. Laura has joyfully experimented with various coloring techniques over the course of her career, winning various and encouraging awards along the way, including an Eisner, Shel Dorf, and Wizard Fan Award. She has colored almost all of Michael's work: *Madman*, *Silver Surfer*, *The Atomics*, *FF*, *Daredevil*, *Wolverine and the X-Men*, *X-Statix*, *Art Ops*, *Red Rocket 7*, *It Girl*, and *iZOMBIE*. But she's also colored for other artists like Art Adams, Geof Darrow, Seth Fisher, and Joëlle Jones.

Michael Allred has been making comics fulltime since January of 1990. This is when his "hobby" drawing comics started paying well enough to roll the dice and leave his previous career as a TV journalist in Europe. He relocated back to the US to be a cartoonist while also dipping his toe in film, as well as recording two albums with his band, The Gear.

The move from Europe was justified soon after with the success of his Frank "Madman" Einstein creation, and the successful coloring career of his wife and partner, Laura Allred. The Eisner, Harvey, and Inkpot award-winning couple have worked together on several acclaimed titles including *The Atomics*, *Red Rocket 7*, *FF*, *Batman*, and *Silver Surfer*. Michael Allred, along with Chris Roberson, also co-created *iZOMBIE*, which is now a hit TV series.

Daniel Bayliss is a comic book artist and illustrator from Mexico. He studied architecture at Universidad de Sonora, and came to notoriety after working on the *Batman* fan fiction "The Deal," written by Gerardo Preciado. He made his debut on the BOOM! Studios miniseries *Translucid*, written by Chondra Echert and Claudio Sanchez. He also worked on the *Mighty Morphin Power Rangers* #0 backup story, written by Mairghread Scott, *Jim Henson's The Storyteller: Dragons*, and recently completed the BOOM! Studios series *Kennel Block Blues* alongside writer Ryan Ferrier.

Kelsey Beckett is a Michigan native and an illustration graduate of the College for Creative Studies. She is a freelance illustrator and fine artist who has shown work in

galleries across the country. She works mainly in acrylic, oil, and digital mediums.

Matías Bergara was born, and is currently living, in Montevideo, Uruguay. An illustrator, comic book and video game artist, he has produced art for BOOM! Studios, DC Comics/Vertigo, Neil Gaiman's *Odd and the Frost Giants*, and Humanoids. He is currently working on creator-owned books to be published in the United States and Europe.

Mark Buckingham has been working in comics for over twenty-eight years, building a reputation for design, storytelling, and a chameleon-like diversity of art styles on titles like *The Sandman*, *Death*, and *Peter Parker: Spider-man*. Since 2002, Mark has been the regular artist on *Fables* for Vertigo/DC Comics, working with its writer and creator Bill Willingham, for which they have earned numerous comic industry awards. Mark recently reunited with Neil Gaiman as they returned to work, after a twenty-two year wait, on *Miracleman* for Marvel Comics.

Dylan Burnett is a comic book artist from Toronto, Canada. He is currently working on *Weavers* for BOOM! Studios, and is also known for his work on *Interceptor* with Heavy Metal Comics. He is also a longtime member of the Toronto comics artist collective *Fromahat Studio*, and contributor to the short story blog *Lunchbox*. When he's not drawing comics, Dylan's probably listening to punk rock music or playing Zelda.

Jane Burson is passionate about art, historic costumes, and fan culture. She lives in Austin, Texas with two cats, twelve chickens, more garden than she can handle, and is doing her solid best to make her life as ridiculous as possible, one day at a time. Find more of her work at www.janeburson.com.

Jonathan Case is an Eisner Award-winning cartoonist whose work includes graphic novels, prose, and paintings. He began a succession of critically acclaimed books with his

first graphic novel, *Dear Creature*, followed by *Green River Killer*, *Batman '66*, and *The New Deal*. An Oregon native, Jonathan has dozens of paintings and murals throughout Portland hotspots. In 2015, the city's TEDx event honored him as their featured artist.

Hannah Christenson creates illustrations for books, comics, editorial, and games. Her work has been recognized by a variety of publications including *The Society of Illustrators* and *Spectrum*. When she's not working, Hannah can most often be found adventuring on some side-quest in search of treasures with her trusty canine sidekicks.

Katie Cook is a comic artist and writer that hails from the mitten state (which is Michigan, not that she is in the state of being a mitten). She is the creator of the comic *Gronk: A Monster's Story* as well as working on IDW's *My Little Pony: Friendship is Magic*. She has also done work for Marvel, LucasFilm, *Fraggle Rock*, and so much more! Her mother thinks she is funny. She can be found online at www.katiecandraw.com.

Jorge Corona is the Russ Manning Award-winning artist behind *Feathers*, *Goners*, and *We Are Robin*. He's also worked on titles such as *Bravest Warriors*, *Justice League Beyond*, and *Teen Titans GO!*, as well as the closing chapter of *Jim Henson's The Storyteller: Dragons*. Originally from Venezuela, he currently lives in his hometown, Maracaibo.

I.N.J. Culbard is an award-winning artist and writer. He is the artist of acclaimed series *Brass Sun* for 2000 AD, written by Ian Edginton, and has collaborated with Dan Abnett on several projects including *Wild's End*, *The New Deadwardians*, *Dark Ages*, and *Brink*. His first solo original graphic novel, *Celeste*, published by SelfMadeHero, was nominated for the British Comics Awards in 2014.

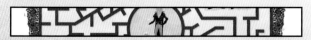

Max Dalton is a graphic artist living in Buenos Aires, Argentina by way of Barcelona, New York, and Paris. He has been drawing since he was two or three, and

began to take it seriously around the age of thirteen. In the last twenty years, he has been involved in several projects like drawing humor strips for a local magazine, creating animations for television, doing some editorial illustration, and, most of all, working on personal artistic projects.

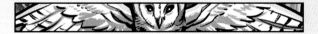

Benjamin Dewey prefers most cats to most people. He remains optimistic about his semi-curmudgeonly perspective changing over time because his lovely wife Lindsey has proven, in their ten years together, that some humans can be pretty cool. Guitars, comics, books on science, berries, the occasional video game, and movies about robots take up what downtime he is able to chisel out of a very busy schedule. Dewey is best known for illustrating titles such as *The Autumnlands* and *I Was The Cat*, and as the author/artist of the surrealist olde-timey humor-comic, *The Tragedy Series*. *Labyrinth* was a major influence on him as child and, if one looks carefully, it's influence is still apparent in his contemporary work.

Michael Dialynas is a comic artist and beast wrangler that resides in Athens, Greece. In his native tongue he has published the graphic novel *Trinkets: An Attic Full of Stories* and the series *Swan Songs*, both from Comicdom Press, but he is more known for his work on the mini-series *Amala's Blade* for Dark Horse Comics, *Spera* at Archaia, and on Marvel's Superior *Spider-Man Team Up Special*. He is currently illustrating *The Woods* with James Tynion IV, over at BOOM! Studios, and has just recently finished working on a few issues of *Teenage Mutant Ninja Turtles* for IDW, and DC's *Gotham Academy*. When he is not chained to the desk drawing comics, he tries to live a normal life and see the Earth's yellow sun. You can find more of his work at WoodenCrown.com.

Gustavo Duarte is a cartoonist and a comic creator born in São Paulo, Brazil. For the last twenty years, he has published comics and illustrations in the most important publications in Brazil. In 2009, he started publishing his own comics like *Monsters!*, *Có!*, *Birds*, and others. He published a collection of his short stories in *Monsters! and Other Stories* through Dark Horse Comics, and has worked with DC Comics, Marvel, and BOOM! Studios.

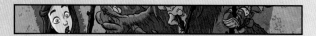

Jay P. Fosgitt is the creator of *Bodie Troll* and *Dead Duck and Zombie Chick* (Source Point Press), has done artwork for *Sesame Street* (Ape), *The Amazing World of Gumball* and *Adventure Time* (BOOM!), *My Little Pony* and *Popeye* (IDW), and *Avengers Standoff* and *Rocket Raccoon and Groot* (Marvel).

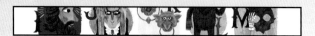

Luke Flowers is an illustrator from Colorado Springs, Colorado. He spends his days/nights in his creative cave illustrating for children's books, publications, and gallery shows. The artistry of The Jim Henson Company has truly been a lifelong source of inspiration to Luke on his own creative journey. Visit lukeflowerscreative.com to view more of his unique work.

Lily Fox lives on Oahu, Hawaii with her husband and wonderful son, David, who is already being raised to love *Labyrinth* and all *Muppet*-related endeavors. See more of her work at www.gingerhaole.etsy.com.

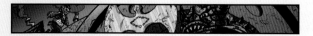

Matthew Fox is the illustrator and co-creator of the Eisner Award-nominated graphic novel *Long Walk to Valhalla* (BOOM!/Archaia,) and illustrator of the mini-series *Ufology* (BOOM!). He lives and works in Kansas City.

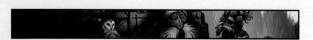

Cory Godbey creates fanciful illustrations for films and books, including *Labyrinth Tales* from BOOM! Studios. His award-winning work has been featured in many esteemed annuals, including *Spectrum: The Best in Contemporary Fantastic Art* and *The Society of Illustrators*. He enjoys meeting new creatures and hikes through twisting paths with friends. Cory lives with his wife, son, and a pack of stray cats in Greenville, South Carolina. He can be found online at www.corygodbey.com.

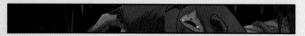

Ian Herring split his youth between small town Ontario and smaller town Cape Breton, Canada and was raised on Nintendo and reruns of *The Simpsons*. Somewhere during this time, he learned to draw. Currently based in Toronto, go Raptors!

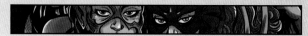

Faith Erin Hicks is a writer and artist living in Vancouver, British Columbia. Her previous works include *Friends with Boys*, *Nothing Can Possibly Go Wrong*, *The Last of Us: American Dreams*, and the Eisner Award-winning *The Adventures of Superhero Girl*. She is currently working on a graphic novel trilogy called *The Nameless City*.

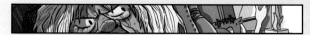

Justin Hilden lives and works in Los Angeles. He is an illustrator and graphic designer at The Jim Henson Company and loves working with classic Henson properties like *Labyrinth*. He also creates animated shorts and collaborates with his wife, writer Autumn Hilden, in their cottage studio. See more of his work at www.justinhilden.com.

Douglas Holgate is a comic book artist and cartoonist based in Melbourne, Australia. He's worked on comics published by BOOM! Studios, Image, Dynamite, Random House, and Abrams Books and is currently drawing *Clem Hetherington* and *The Ironwood Race*, an all-ages graphic novel co-created with Jen Breach and to be published by Scholastic Graphix in 2017. See more of this work at www.skullduggery.com.au or on twitter @douglasbot.

Mike Huddleston is an award winning illustrator, and has worked for every comic book company he can think of. Most of the time he's working on stuff like *Harley Quinn*, or *The Strain*, but occasionally he creates his own projects like *The Coffin*, with Phil Hester, or *Butcher Baker*, with Joe Casey. He lived in France for awhile, which was pretty weird, and now lives in Hollywood, which sounds way more glamorous than it really is.

Frazer Irving has been drawing pictures on paper, walls, school books, and computer screens since it was cool to wear flares. He has drawn superheroes, monsters, gods, and talking zombie teddy bears. His favorite colors are purple, magenta, and teal.

Rebekah Isaacs graduated from the Sequential Art program at the Savannah College of Art and Design in 2005 and worked on several series for Devil's Due before landing her first mainstream jobs with *Ms. Marvel #38* and *DV8: Gods & Monsters* with writer Brian Wood. Since then, she has been the series artist on *Joss Whedon's Buffy the Vampire Slayer* (Season 10) and *Angel & Faith* (Season 9), both with writer Christos Gage. Rebekah lives in Queens, NY with her husband, Josh, and their cats, Donut and Nino.

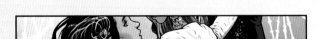

Dan Jackson has been coloring comics, to one degree or another, for going on twenty years. His work includes such titles as *Star Wars*, *Hellboy*, *X-Men*, *Buffy the Vampire Slayer*, *The Terminator*, and *Aliens*. He lives in the Pacific Northwest with his astonishing wife, two absurd children, and a stray dog.

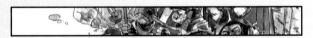

Tyler Jenkins is a Canadian cartoonist and illustrator living the backwoods of the western prairies with his wife and three wild animals who claim to be his offspring. He is at least partially responsible for several comic series, including *Snow Angel* and *Peter Panzerfaust* with Kurtis Wiebe, *Neverboy* with Shaun Simon, and *Snow Blind* with Ollie Masters. You can also find his work in numerous anthologies, including the Eisner-nominated *In The Dark* by Rachel Deering, and on various covers and pinups. He also plays guitar. Loudly and poorly. He has no pets.

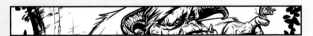

Joëlle Jones is an Eisner-nominated artist currently living and working in Los Angeles, CA. Since attending PNCA in Portland, Oregon, she has contributed to a wide range of projects and has most recently began writing and drawing her own series, *Lady Killer*, published by Dark Horse Comics. Jones has also provided the art for *Superman: American Alien* (DC Comics), *Helheim, Brides of Helheim* (Oni Press), and *Mockingbird* (Marvel). She's also done work for BOOM! Studios, *The New York Times*, and Vertigo, among others. In 2016, Jones will be taking on projects for both DC Comics and Marvel as well as continuing her series, *Lady Killer*.

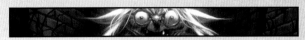

Derek Kirk Kim is an award-winning writer, artist, and filmmaker. He is the writer of the *Tune* series, the writer and director of the spin-off web series, *Mythomania*, and a character designer of *Adventure Time*. He won all three major comics industry awards, the Eisner, the Harvey, and the Ignatz Award for his debut graphic novel, *Same Difference and Other Stories*. He won a second Eisner Award for his work on *The Eternal Smile*, a collaboration with National Book Award-nominee, Gene Luen Yang. He eats chips with chopsticks. His work can be found online at derekkirkkim.com.

Roger Langridge is probably best known for his work on *The Muppet Show Comic Book*, *Thor the Mighty Avenger*, and for his Eisner Award-winning series *Snarked!* His most recent book is a new take on the Sherlock Holmes canon, *The Baker Street Peculiars*, with artist Andy Hirsch.

Tula Lotay is the pen name of Lisa Wood, an artist residing in the Spa Town of Ilkley, West Yorkshire, in Northern England. Her work includes *Supreme Blue Rose* with Warren Ellis from Image Comics and *The Wicked + The Divine #13*, with Kieron Gillen, Jamie Mckelvie, and Matt Wilson, among various anthology works for Vertigo and Image. She is currently working on a new book with Warren Ellis called *Heartless*. She will also be working on *All Star Batman* with Scott Snyder in the Fall. Lisa runs the world-renowned Thought Bubble Festival, a comic art festival which takes place every November in Leeds, UK.

David Mack is the *New York Times* bestselling author of the *Kabuki* graphic novels, the writer of *Daredevil* from Marvel Comics, and cover artist of *Fight Club 2*.

Ann Marcellino is an experienced illustrator and concept artist who has worked in television, mobile games, books, toy design, and a range of other projects. To see more of her work, find her on tumblr at annmarcellino.tumblr.com.

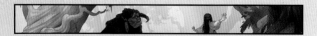

Kelly and Nichole Matthews are a twin art duo living north of the Emerald City. They are the artists for Archaia's *Toil and Trouble* and *Breaker* for Stela Comics. They've drawn comic book covers for Valiant Comics's *Faith* miniseries and the BOOM! Box/DC Comics crossover event *Gotham Academy/Lumberjanes*.

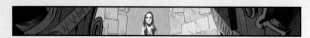

Jonas McCluggage hops trains and draws comics and wears the same clothes everyday. You can find more of his work at jonasgoonface.tumblr.com.

Dave McKean is the illustrator on critically acclaimed graphic novels *Violent Cases*, *Signal to Noise*, and *Mr. Punch* with writer Neil Gaiman and *Arkham Asylum* with writer Grant Morrison. McKean wrote and illustrated the award-winning *Cages*, *Pictures That Tick*, and *Pictures That Tick 2*. He's also collaborated on children's books with Gaiman (*The Day I Swapped My Dad for Two Goldfish* and *The Wolves in the Walls*) and Stephen King (*Wizard & Glass*). He also reunited with Gaiman on the feature film *MirrorMask*. His latest graphic novel, *Black Dog: The Dreams of Paul Nash*, is in stores now.

Dylan Meconis is a cartoonist and writer living in Portland, Oregon. She is the creator of original graphic novels *Family Man*, *Bite Me!*, and *Outfoxed*. Find more of her work online at www.dylanmeconis.com or at your local comic book store.

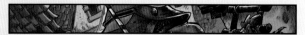

Robb Mommaerts is a cartoonist and illustrator living and working in the frigid state of Wisconsin. When he's not chasing after his two young kids, he's drawing silly pictures down in his office/dungeon. The worlds of Jim Henson and Brian Froud have always had a huge impact on his creative development.

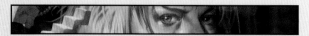

Steve Morris is a professional artist, designer, and art director working in both web content and print. He's worked extensively with Dark Horse Comics producing covers for Joss Whedon's *Buffy the Vampire Slayer*, *Angel & Faith*, *Dollhouse*, and *Serenity*. Additional titles include *The*

Occultist, *House of Night*, and *Fight Club 2* from acclaimed novelist Chuck Palahniuk.

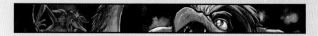

Jake Myler is hopelessly addicted to coffee and despises sunlight, so it makes perfect sense that he settled down in Seattle, Washington. Jake has illustrated the graphic novels *Undertown* and *Orphan Blade*, as well as the comics *Finding Nemo* and *Fraggle Rock*!

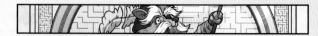

Phil Murphy is probably best known for his work on various titles from BOOM! Studios such as *Adventure Time*, *Munchkin*, *The Amazing World of Gumball*, and *Uncle Grandpa*. His most recent work can be seen in the *Adventure Time* graphic novels including *Adventure Time: President Bubblegum*. Follow him on Twitter @crashtesterX.

Dustin Nguyen is a *New York Times* bestselling comic book artist whose work includes *Batman*, *Superman/Batman*, *Detective Comics*, and *Batgirl*. He is also credited for co-writing and illustrating *Justice League Beyond*, illustrating *American Vampire: Lord of Nightmares* with writer Scott Snyder, and co-creating with Derek Fridolfs, DC Comics' all ages series *Batman: Lil Gotham*. Fridolfs and Nguyen reunited for the bestselling all ages book *Secret Hero Society* from Scholastic. Nguyen, along with Jeff Lemire, is also co-creator of the smash hit series *Descender* from Image comics, and in 2016, published his first children's picture book from KaBOOM!, *What Is It?*, written by his wife, Nicole Hoang.

Ramón K. Pérez is a multiple Eisner and Harvey Award-winning cartoonist best known for his graphic novel adaptation of *Jim Henson's Tale Of Sand*. Other notable works include *All-New Hawkeye*, *Spider-Man: Learning To Crawl*, *John Carter: The Gods Of Mars*, along with *Butternutsquash* and *Kukuburi*.

Eric Powell is a writer and artist from Nashville, Tennessee who has contributed work for every major publisher in the comics industry. But Eric didn't find true success until he launched his critically acclaimed creator-owned series *The Goon* in 1999. Eric

continues working on various *Goon* related projects as well as other books such as *Big Man Plans* with co-writer Tim Wiesch, *Chimichanga* with artist Stephanie Buscema, and *Hillbilly* for his own imprint, Albatross Funnybooks. Eric has been working in collaboration with acclaimed director David Fincher, Blur Animation, and Dark Horse Entertainment to bring *The Goon* to life on the big screen as an animated feature film.

Aaron Renier was born and raised in Green Bay, Wisconsin. He is the creator of two graphic novels, *Spiral-Bound* and *The Unsinkable Walker Bean*. Today he spends most of his time working to finish projects, walking an old dog named Tanuki around a lagoon, and teaching comics and drawing in Chicago, Illinois.

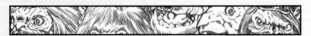

Alex Sheikman was born in the USSR, immigrated to the US at the age of twelve, and shortly thereafter discovered comic books. Since then, he has contributed illustrations to a variety of role-playing games published by White Wolf, Holistic Design, and Steven Jackson Games. He is also the writer and artist of *Robotika*, *Robotika: For A Few Rubles More*, *Moonstruck*, and a number of short stories. He was also the interior artist on *The Dark Crystal: Creation Myths* trilogy from Archaia. He lives in Northern California.

Hayden Sherman is a comic artist and illustrator nudging his way into the comic book field with a love of telling stories. Inspired by science fiction, ancient myths, and aging legends, Hayden is working to bring new stories to a world that is already full of so many incredible tales.

Bill Sienkiewicz is an Emmy-nominated, Eisner Award-winning artist/author. A descendant of Nobel Prize-winning novelist Henryk Sienkiewicz, Bill is best known for redefining the visual language of comics, expanding its boundaries as an art form, and influencing new generations of creators. He also works in Film, TV, Music, and has exhibited worldwide.

Jeff Stokely is the Eisner and Harvey Award-nominated co-creator of *The Spire*, and artist of *Six-Gun Gorilla*, and

The Reason for Dragons. Hailing from central California, Jeff taught himself to draw to the background noise of '90s anime and heavy metal. He can be found chained to his desk, inhaling unhealthy amounts of coffee, pizza, and shonen manga. (Often at the same time.) Jeff currently resides in Seattle, Washington with his majestic beard and definitely not fictional girlfriend.

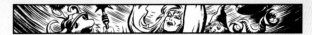

Craig Thompson was born in Michigan in 1975. He is the writer and artist of the critically acclaimed graphic novels *Blankets*, *Habibi*, *Space Dumplins*, *Good-bye, Chunky Rice*, and *Carnet de Voyage*. He was awarded three Eisner awards, three Harvey awards, two Ignatz awards, and a Grammy nomination for album cover artwork on Menomena's Friend and Foe. He lives in Los Angeles.

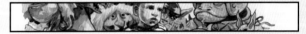

Jill Thompson is an Award-winning comic book artist and a storyteller best known for *Scary Godmother*, *Magic Trixie*, *The Sandman*, and *Beasts of Burden*.

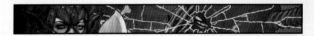

Jim Towe is a comic book artist from Detroit, Michigan. His work has been published by BOOM! Studios, Top Cow Productions, and various small press and independent outlets. He draws a lot.

Kyla Vanderklugt was born, raised, educated, and partially civilized in Toronto, Canada before she moved to rural Ontario to work as a freelance illustrator in the countryside and forget all her manners. Her comics work includes contributions to the *Flight*, *Nobrow*, and *Mouse Guard: Legends of the Guard* anthologies, *Spera*, *Jim Henson's The Storyteller: Witches*, and various self-published shorts.

S.M. Vidaurri was born and raised in northern New Jersey. His previously published works include *Jim Henson's The Storyteller: Witches* and the original graphic novels *Iron: Or, the War After* and *Iscariot*. His apartment is filled with many animals. He can be found at www.smvidaurri.com and on twitter @smvidaurri.

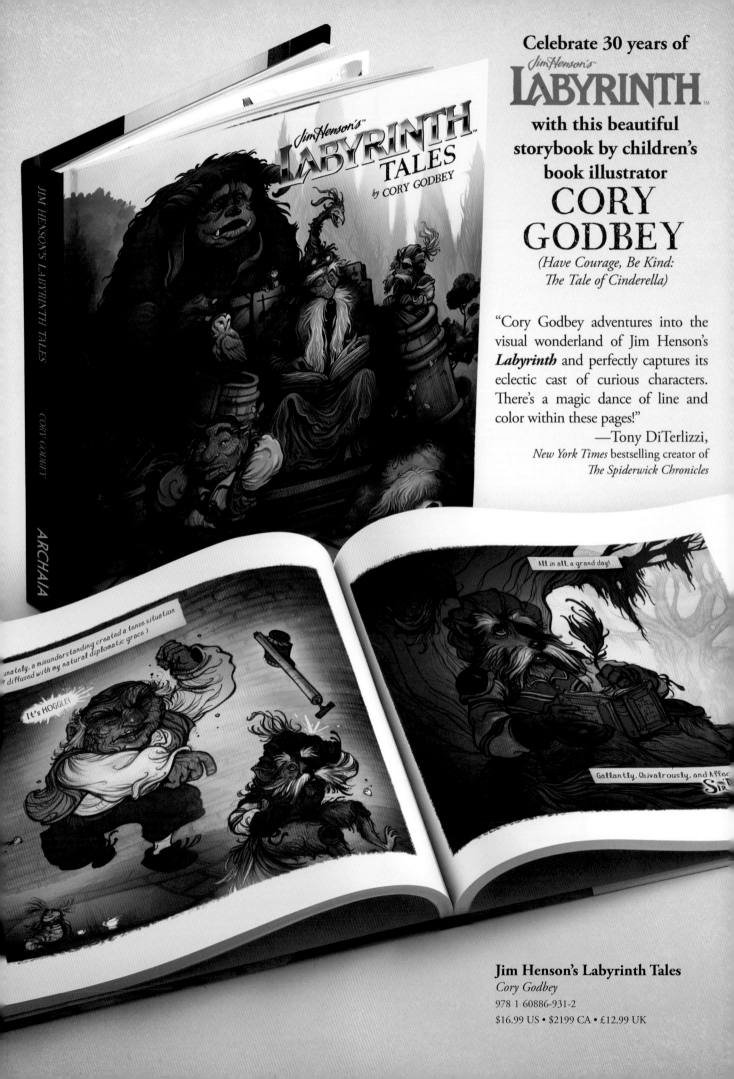

MORE FROM ARCHAIA
AND THE JIM HENSON COMPANY

Jim Henson's The Dark Crystal: Creation Myths
Brian Holguin, Joshua Dysart, Matthew Dow Smith, Alex Sheikman
Vol. 1: 978-1-60886-704-2
$14.99 US • $19.99 CA • £10.99 UK

Vol. 2: 978-1-60886-887-2
$14.99 US • $19.99 CA • £10.99 UK

Vol. 3: 978-1-60886-906-0
$14.99 US • $19.99 CA • £10.99 UK

Jim Henson's The Storyteller: Dragons
Daniel Bayliss, Hannah Christenson, Nathan Pride, Jorge Corona
978-1-60886-874-2
$24.99 US • $32.99 CA • £18.99 UK

Jim Henson's The Storyteller: Witches
S.M. Vidaurri, Kyla Vanderklugt, Matthew Dow Smith, Jeff Stokely
978-1-60886-747-9
$24.99 US • £18.99 UK

Jim Henson's Tale of Sand
Jim Henson, Jerry Juhl, and Ramón K. Peréz
Tale of Sand: 978-1-60886-439-3
$25.95 US

The Illustrated Screenplay: 978-1-60886-440-9
$24.99 US • £18.99 UK

Tale of Sand Box Set: 978-1-60886-439-3
$49.99 US • £37.99 UK